Seventeenth-Century
DUTCH AND FLEMISH DRAWINGS
From the Robert Lehman Collection

CATALOGUE BY
GEORGE SZABO

THE METROPOLITAN MUSEUM OF ART
NEW YORK
1979

Cover: Rembrandt Harmensz van Rijn, No. 22

INTRODUCTION

This is the fourth exhibition in a series through which all the drawings in the Robert Lehman Collection will eventually be shown. The sixty-six works represent all our holdings by the seventeenth-century Dutch and Flemish masters.

This is an especially prominent and cohesive group, representing the art of draftsmanship in the Netherlands. It includes more than ten drawings by Rembrandt, half a dozen each by Jordaens, Jan van Goyen, and Willem van de Velde. Other prominent artists such as van Loo, Ostade, and Roghman are represented by fewer drawings. Many of these are well known and extensively published; however, some are shown here for the first time or have not been exhibited for decades.

Rembrandt's drawings illustrate his entire life and career. The *Self-Portrait* and the *Satire on Art Criticism* are highly important personal documents, while *The Last Supper* after Leonardo and the *Cottage near the Entrance to a Wood* are also two monuments of seventeenth-century Dutch art.

Rubens's *Bust of Seneca* (?) and Rembrandt's *Last Supper* are reminders of the seventeenth-century artists' interest in classical antiquity and in the great achievement of the Italian Renaissance.

Jordaens's religious drawings are moving examples of the reinterpretation of biblical scenes by Protestant artists.

A fascination with and involvement in contemporary life is clearly mirrored in the landscapes of van Goyen, the genre scenes of Jordaens and Ostade, and even in such gruesome subjects as Rembrandt's *Woman on the Gallows*. History is reflected in the depictions of sea battles by van de Velde and in *The Triumphal Entry of Frederik Hendrik of Orange into The Hague* by Vinckboons or in the studio still life by Jan Fyt.

This catalogue fully illustrates not only all the exhibited drawings but also the versos, which cannot be shown. The attributions are mostly those assigned to the drawings during Robert Lehman's lifetime, but often the results of recent research is also mentioned and incorporated into the brief descriptions and comments. The selected bibliographies supply further information about provenance and literature.

Some of the drawings are exhibited in seventeenth-century frames; others are shown in Dutch, Flemish, and occasionally Italian frames. A selection of ceramics, textiles, and furniture related to the drawings or to their

context is also exhibited. All these objects are from the Robert Lehman Collection.

The exhibition was organized and the catalogue was prepared by the staff of the Robert Lehman Collection. The design of the catalogue and posters is by Doris Halle of the Department of Design.

Mounting of the drawings and conservation is by the Department of Paper Conservation.

George Szabo
CURATOR
ROBERT LEHMAN COLLECTION

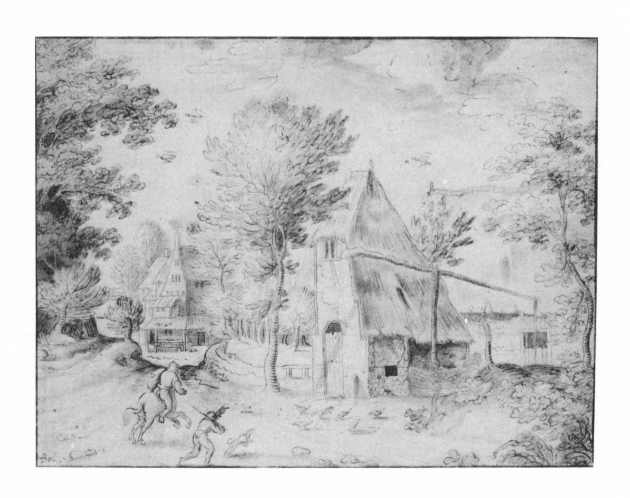

FERDINAND BOL, Dutch, Amsterdam, 1616–1680

1. *Travelers at a Village*

Pen and brown ink with wash on paper, 15.3 × 21 cm. Signed in lower left corner: *Bol.*
Unpublished.

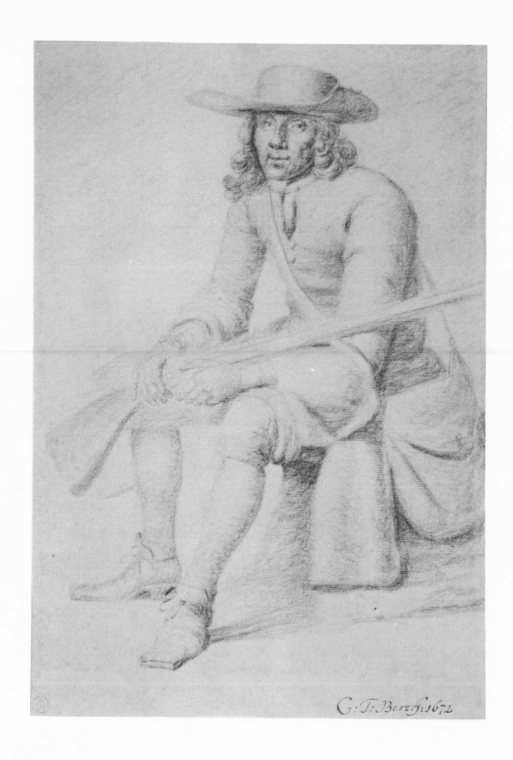

GESINA TER BORCH, Dutch, Zwolle, Deventer, 1633–1690

2. *A Seated Huntsman*

Black chalk with white highlights on gray paper, 27 × 18.5 cm. Signed and dated in pen and ink in lower right corner: *G:T:Borch:1672*.

BIBLIOGRAPHY: F. Muller & Co., *Sammlung C. Hofstede de Groot Auktionskatalog,* Berlin, May 1913, lot 28; F. Lugt, "Beitrage zu dem Katalog der Niederlandischen Handzeichnungen in Berlin," *Jahrbuch der Preussischen Kunstsammlungen,* 52 (1931), p. 41; *Tricolour,* no. 1, ill.

Gesina Ter Borch was the sister of the painter Gerard Ter Borch, who is represented in the Robert Lehman Collection by a pair of portraits (see Guidebook, pp. 74–75). This finely executed drawing demonstrates that she possessed the same talents as her brother: penetrating observation and great technical skill.

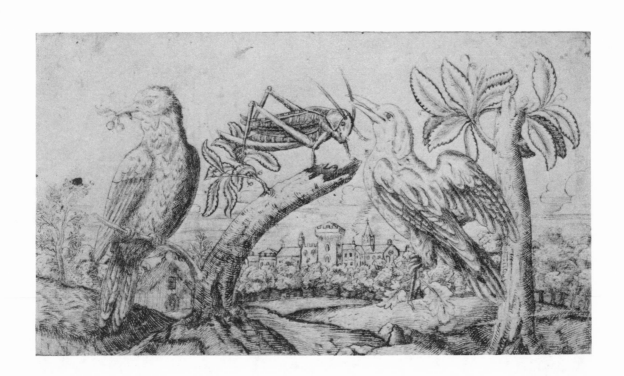

NICHOLAS DE BRUYN, Dutch, Antwerp, Rotterdam, Amsterdam, 1565–1656

3. *Two Birds and a Cricket*

Pen and brown ink on paper, 14.3 × 25.4 cm.

BIBLIOGRAPHY: Seiferheld Gallery, *Animal Drawings from the XV to the XX Centuries*, New York, 1962, ill.; *Tricolour*, no. 2.

It is generally assumed that this drawing was made for the series of bird engravings entitled *Volatilium Varii Generis Effigies*, published in 1594. However, the drawing was not in the series and was never engraved.

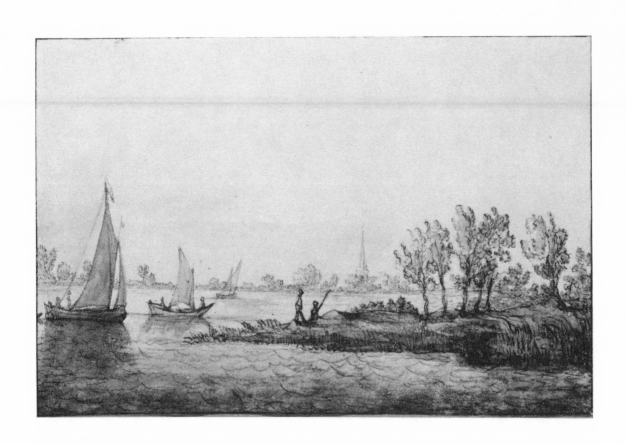

AELBERT CUYP, Dutch, Dordrecht, 1620–1691

4. *River Landscape with Sailboats*

Black chalk and watercolor on paper, 12 × 18.6 cm. Signed in pen and ink in lower right corner:
A. Cuyp.

BIBLIOGRAPHY: *Tricolour*, no. 4.

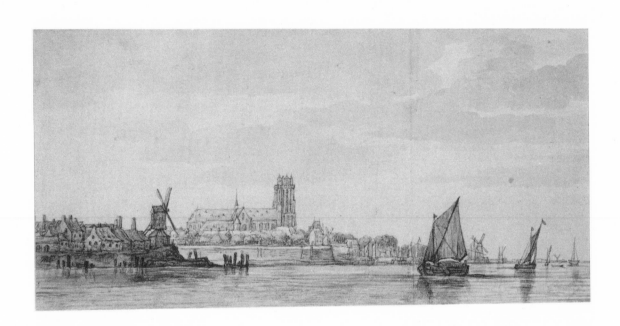

AELBERT CUYP, Dutch, Dordrecht, 1620–1691

5. *View of Dordrecht with the "Grote Kerk"*

Black chalk and watercolor on paper, 17.4 × 36 cm.

BIBLIOGRAPHY: J. G. van Gelder and I. Jost, "Doorzagen op Aelbert Cuyp," *Nederlands Kunsthistorisch Jaarboek* 23 (1972), pp. 227, 238, fig. 5; *Tricolour,* no. 3.

This broad panoramic view of the artist's native town is closely related to several of his other drawings and paintings. These relationships are pointed out by van Gelder and Jost, who date the drawing to about 1650.

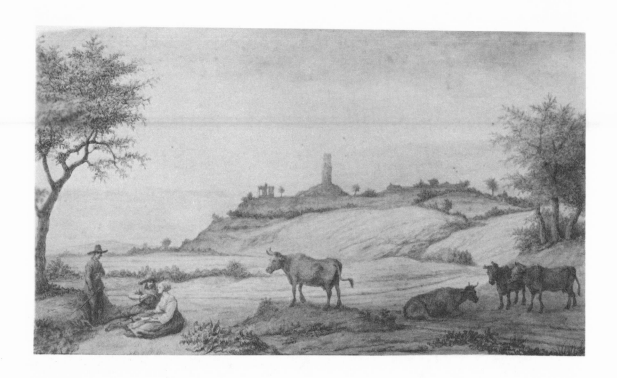

LAMBERT DOOMER, Dutch, Amsterdam, Alkmaar, 1622/23–1700

6. *View of the Monterberg with the Ruined Castle of the Counts of Cleve*

Pen and ink with watercolor on paper, 23.5 × 40.5 cm. Inscribed on the verso by a later (eighteenth-century?) hand: *De Monterenbergh van Kalker af te zien*. Watermark: pigeon.

BIBLIOGRAPHY: W. Spiess, "Lambert Doomer Rheinlandschaften. Zweite Folge," *Wallraf Richartz Jahrbuch* I (1930), pp. 241–243, fig. 229; W. Schulz, *Lambert Doomer, Samtliche Zeichnungen*, Berlin, 1974, no. 197, fig. 102; *Tricolour,* no. 5; W. Schulz, "Lambert Doomer als Maler," *Oud-Holland* 92 (1978), pp. 90, 96, 99, fig. 23.

This highly finished and carefully elaborated drawing is based on a sketch the artist made during his travels through the Rhine region of Germany sometime between 1648 and 1668. W. Schulz, in his comprehensive catalogue of Doomer's drawings, dates it to the early 1670s. The ruins represented are near Calcar; the castle was destroyed in 1635. Schulz suggests that the pastoral scene in the foreground, with the three figures and cows, probably has an allegorical meaning.

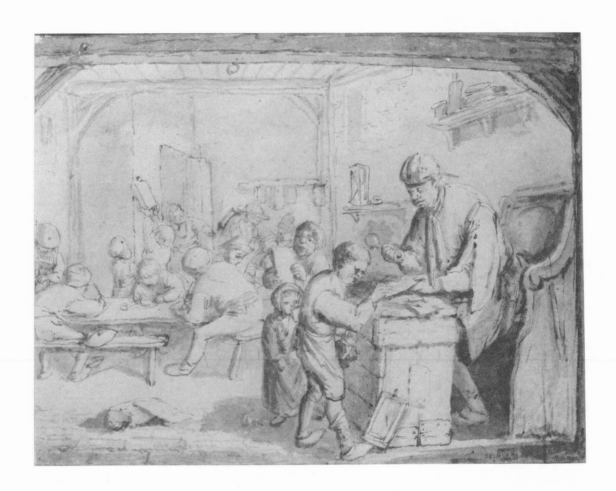

CORNELIS DUSART, Dutch, Utrecht, Haarlem, 1660–1704

7. *The Schoolmaster*

Pen and India ink with wash on paper, 15.2 × 19.7 cm. Signed in pen and ink in lower right corner: *C. dusart.*

BIBLIOGRAPHY: H. G. Gutekunst, *Sammlung D. Peltzer Auktionskatalog*, Stuttgart, May 1914, no. 128, ill.; *Tricolour,* no. 6.

This animated and amusing drawing reflects the influence of Adriaen van Ostade, the artist's teacher. He is also represented in the exhibition by a similar genre scene (No. 20).

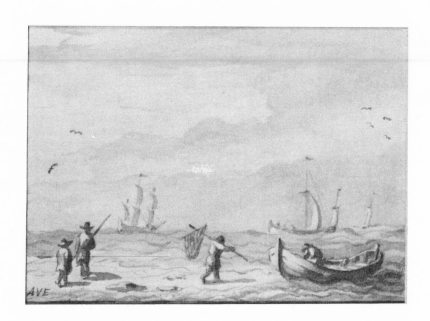

ALLAERT VAN EVERDINGEN, Dutch, Alkmaar, Haarlem, Amsterdam, 1621–1675

8. *Fishing Boats and Man with Net*

Point of brush in shades of brown ink on paper, 6.7 × 9.5 cm. Inscribed with initials in pen and ink in lower left corner: *AVE*.

BIBLIOGRAPHY: *Tricolour,* no. 9.

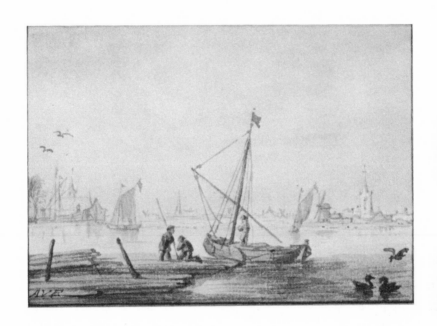

ALLAERT VAN EVERDINGEN, Dutch, Alkmaar, Haarlem, Amsterdam, 1621–1675

9. *Harbor Scene*

Point of brush in shades of brown ink on paper, 6.7 × 9.5 cm. Inscribed with initials in pen and ink in lower left corner: *AVE*.

BIBLIOGRAPHY: *Tricolour,* no. 8.

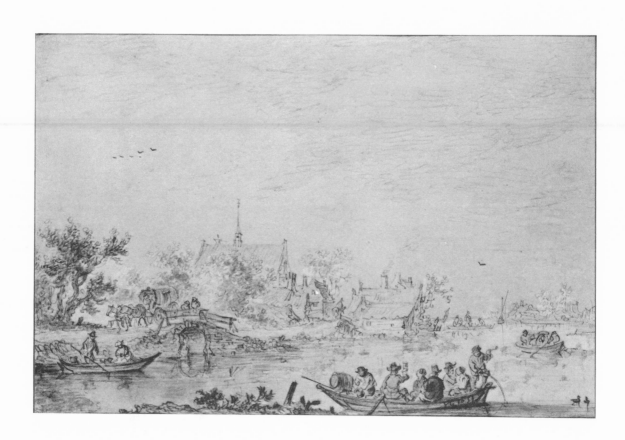

JAN JOSEPHSZ VAN GOYEN, Dutch, Leyden, The Hague, 1596–1656

10. *Boating Party on a River*

Black chalk with watercolor on paper, 11.5 × 19.5 cm. Signed with initials and dated on the stern of the boat in the foreground: *VG 1651*. Watermark: crowned double-headed eagle with the emblem of Basel in a heart.

BIBLIOGRAPHY: H. U. Beck, *Jan van Goyen, Ein Oeuvreverzeichnis*, no. 281, ill.; *Tricolour*, no. 10.

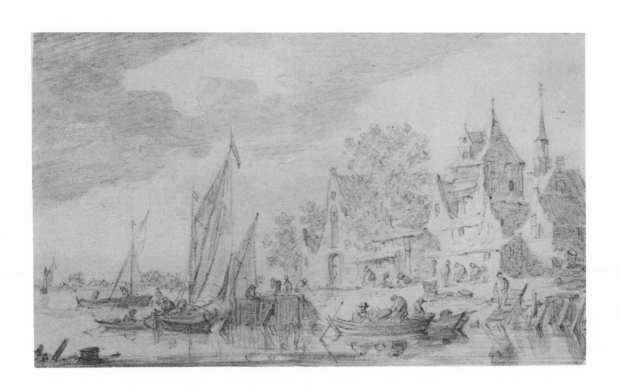

JAN JOSEPHSZ VAN GOYEN, Dutch, Leyden, The Hague, 1596–1656

11. *Landing Place by a Town*

Black chalk with gray wash (perhaps added later) on paper, 11.5 × 19.5 cm.

BIBLIOGRAPHY: R. M. Light and Co., *Dutch and Flemish Drawings, 16th and 17th Centuries*, Boston, 1960, no. 14, ill.; H. U. Beck, *Jan van Goyen, Ein Oeuvreverzeichnis*, no. 725, ill.; *Tricolour*, no. 11.

H. U. Beck dates this quick, animated sketch to about 1650. It is comparable to many oil paintings by the artist.

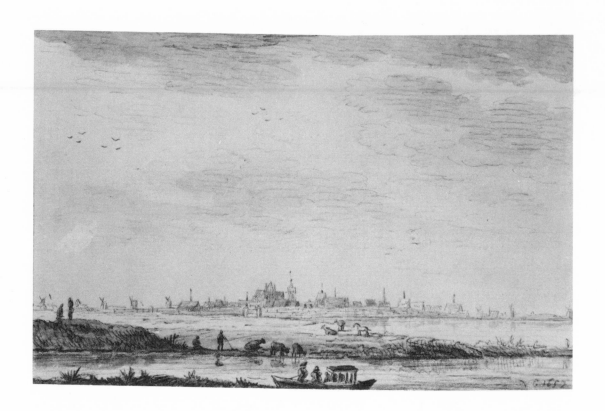

JAN JOSEPHSZ VAN GOYEN, Dutch, Leyden, The Hague, 1596–1656

12. *Landscape with a Distant Town*

Black chalk with ink wash on paper, 13.3 × 21.3 cm. Signed with initials and dated in lower right corner: *VG 1652*.

BIBLIOGRAPHY: *Tricolour,* no. 13.

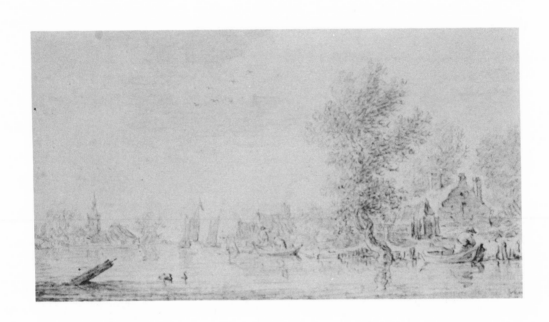

JAN JOSEPHSZ VAN GOYEN, Dutch, Leyden, The Hague, 1596–1656

13. *Village near a River*

Black chalk and pencil on paper, 7.5 × 13.8 cm. Inscribed with monogram in lower right corner: *VG.*

BIBLIOGRAPHY: W. H. Schab, *Graphic Arts of Five Centuries, Prints and Drawings*, New York, 1959, no. 139, ill.; *Tricolour,* no. 14.

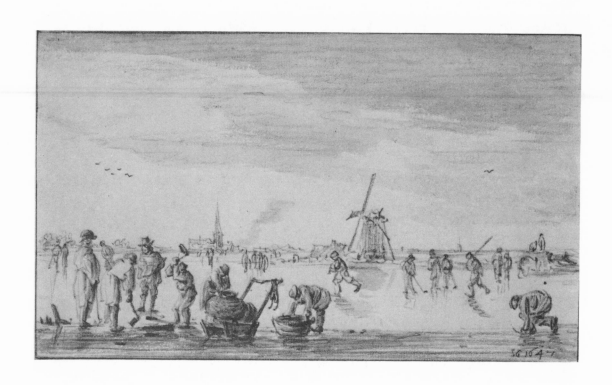

JAN JOSEPHSZ VAN GOYEN, Dutch, Leyden, The Hague, 1596–1656

14. *Winter Landscape with Skaters*

Black chalk with gray wash on paper, 11.5 × 19.5 cm. Inscribed with monogram and dated in lower right corner: *VG 1647.*

BIBLIOGRAPHY: D. Hannema, *Catalogue of the H. E. ten Cate Collection*, Rotterdam, 1955, no. 325; H. U. Beck, *Jan van Goyen, Ein Oeuvreverzeichnis*, no. 167, ill.; *Tricolour*, no. 12.

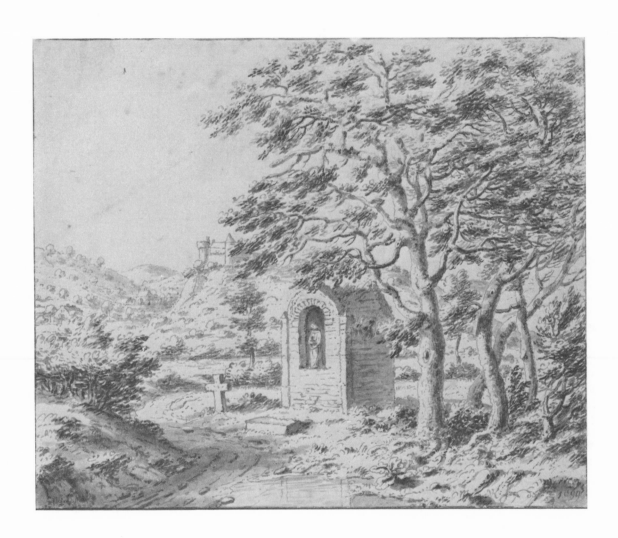

VALENTIN KLOTZ, Dutch, Maastricht, The Hague, about 1669–after 1712

15. *Roadside Shrine and Cross*

Pen and ink with wash on paper, 15.7 × 19.3 cm. Signed with initials and dated (December 29, 1699) in lower right corner: *VK f(ecit) $\frac{12}{29}$ 1699*.

Unpublished.

During the late 1690s the artist traveled extensively in the mountainous regions of southern Flanders and neighboring Germany. The castle on the mountain in the background might indicate that Klotz made this drawing during that period of travel.

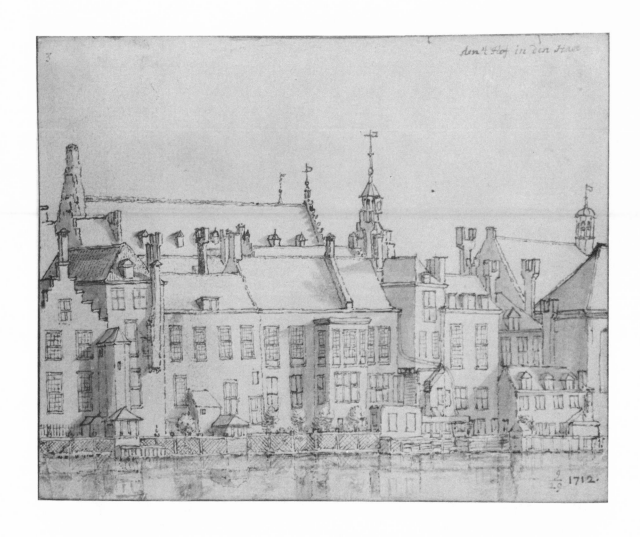

VALENTIN KLOTZ, Dutch, Maastricht, The Hague, about 1669–after 1712.

16. *The Buitenhof in The Hague*

Pen and ink with pale gray wash on paper, 15.3 × 19.7 cm. Inscribed in upper right corner: *den 4 Hof in den Hage*. Dated (September 29, 1712) in lower right corner: $\frac{9}{29}$ *1712*.

BIBLIOGRAPHY: Tricolour, no. 15.

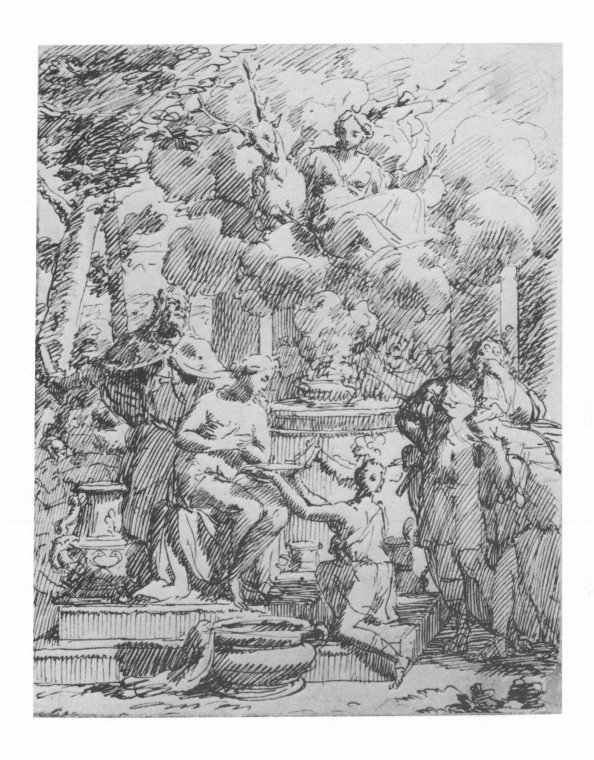

GERARD DE LAIRESSE, Flemish-Dutch, Liege, The Hague, Amsterdam, 1641–1711

17. *The Sacrifice of Iphigenia*

Pen and brown ink on paper, 21.6 × 16.2 cm.

BIBLIOGRAPHY: *Tricolour*, no. 16.

An inscription on the old mat identifies this scene as an illustration of Ovid's *Metamorphoses*, book 12, lines 25–28. In the clouds above the altar is the figure of Diana, who just before the sacrifice substitutes a hind for Iphigenia; see A. Pigler, *Barockthemen* II, Budapest, 1965, p. 307). Lairesse was well known as a painter of mythological subjects. His haunting and searching portrait by Rembrandt, painted in 1665, is in the Robert Lehman Collection (Guidebook, pp. 73–74).

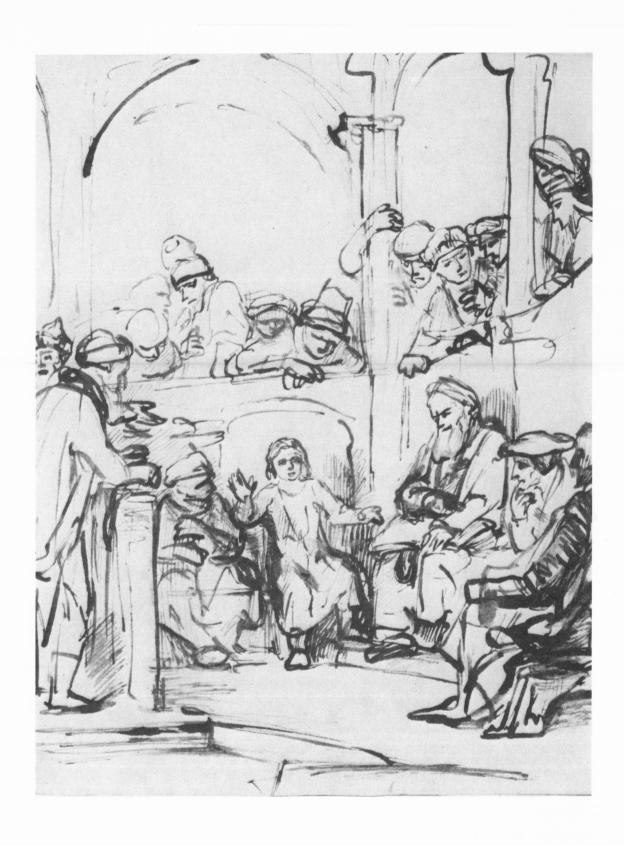

NICOLAES MAES, Dutch, Dordrecht, Amsterdam, 1634–1693

18. *The Twelve-Year Old Christ Among the Doctors*

Pen and bister on paper, 22.6 × 17.8 cm.

BIBLIOGRAPHY: *Tricolour,* no. 17.

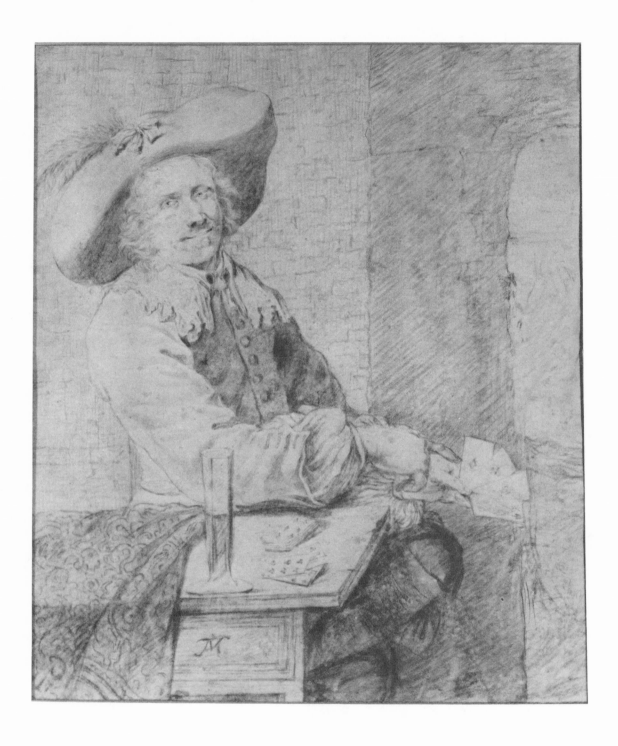

FRANS VAN MIERIS THE ELDER, Dutch, Leyden, 1635–1681

19. *Seated Man Holding Cards*

Black chalk with some color on paper, 17 × 14.8 cm. Inscribed with monogram of interconnected *FVM* on side of table in lower left.

BIBLIOGRAPHY: *Tricolour,* no. 18; O. Naumann, "Frans van Mieris as a Draughtsman," *Master Drawings* 16 (1978), pp. 11, 13, 34, ill.

O. Naumann has suggested that this drawing is not by Mieris and that "the unknown artist probably based himself on the original chalk drawing, as he attempted to imitate the technique of strengthening areas and lines with chalk applied more heavily."

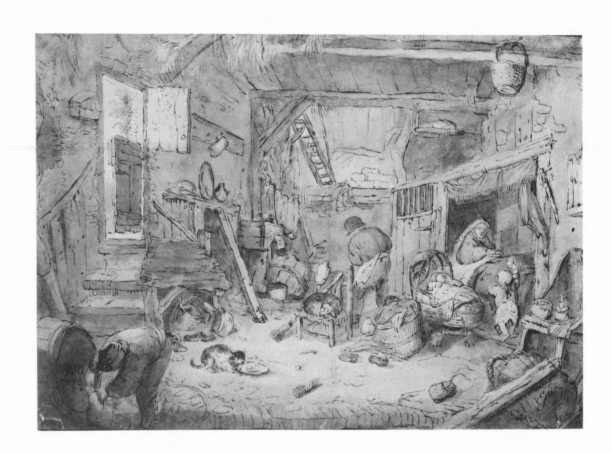

ADRIAEN VAN OSTADE, Dutch, Haarlem, 1610–1684

20. *Interior of a Barn*

Pen and sepia and India ink with watercolor on paper, 27 × 38.1 cm. Inscribed with initials and date on barrel in lower left corner: *AVO 1653*.

BIBLIOGRAPHY: Cincinnati, p. 28, no. 269, ill.; C. T. Eisler, *Drawings of the Masters, Flemish and Dutch Drawings from the XV to the XVIII Century*, New York, 1963, p. 112, ill.; *Tricolour*, no. 19.

This colorful drawing is the most elaborate of the artist's studies of barns (cf. L. Godefroy, *L'oeuvre gravé de Adriaen van Ostade*, Paris, 1930, pp. 52–53). It is also a delightful genre drawing equal to Ostade's paintings.

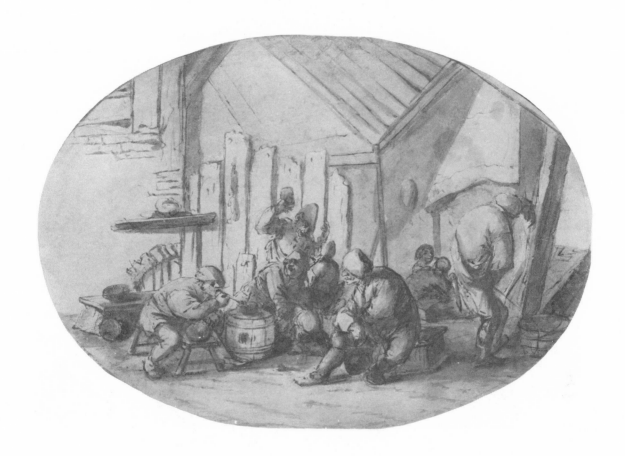

ISAACK VAN OSTADE, Dutch, Haarlem, 1621–1649

21. *Peasants in a Barn*

Pen and ink with traces of black chalk and watercolor on paper, 19.7 × 28.3 cm.

BIBLIOGRAPHY: "The Leroy Backus Collection," *Schaeffer Galleries Bulletin* 9 (1948); *Tricolour,* no. 20.

Like most of the artist's work, this drawing shows the influence of his brother and teacher, Adriaen van Ostade. It is comparable to the elder artist's drawings and engravings (cf. L. Godefroy, *L'oeuvre gravé de Adriaen van Ostade,* Paris, 1930, p. 56, passim).

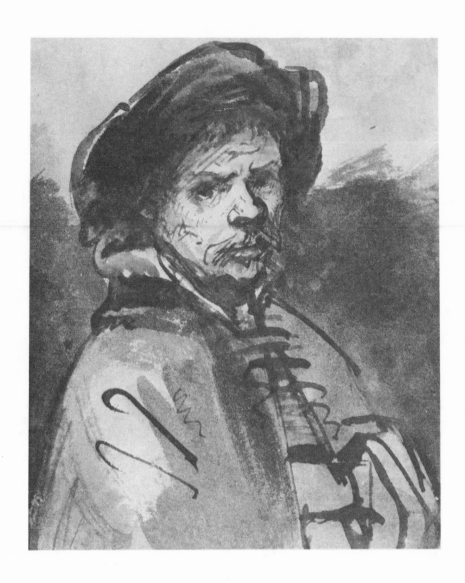

REMBRANDT HARMENSZ VAN RIJN, Dutch, Leyden, Amsterdam, 1606–1669

22. *Self-Portrait*

Pen and brown ink with brown ink and India ink wash on paper, 14.5 × 12.1 cm.

BIBLIOGRAPHY: *R. Kann Collection*, no. 164; O. Benesch, *The Drawings of Rembrandt* II, 1954, no. 434; *Rembrandt Drawings from American Collections*, no. 13; F. Erpel, *Die Selbstbildnisse Rembrandts*, Berlin, 1967, pp. 44–45, 166–167, no. 63; O. Benesch, *The Drawings of Rembrandt* II, 1973, no. 434.

This half-length self-portrait seems to date to around 1636. Despite some later additions in the washes, "the power of this striking self-characterization has not been obscured."

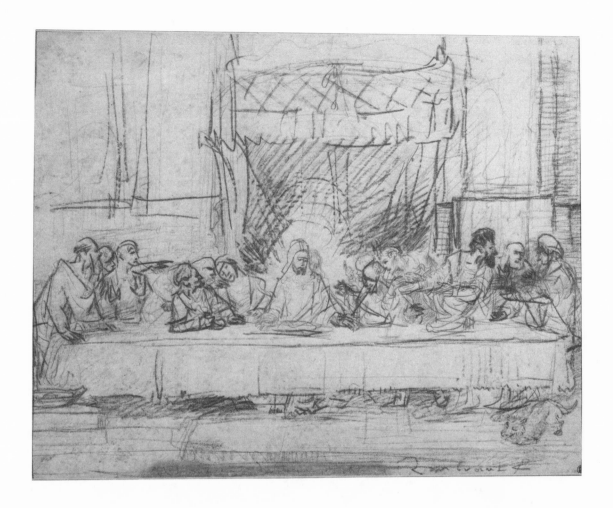

REMBRANDT HARMENSZ VAN RIJN, Dutch, Leyden, Amsterdam, 1606–1669

23. *The Last Supper,* after Leonardo da Vinci

Red chalks on paper, 36.5 × 47.5 cm. Signed in lower right: *Rembrant f.*

BIBLIOGRAPHY: F. Lippmann, *Original Drawings by Rembrandt* I, Berlin, 1889–1892, no. 99; O. Benesch, *The Drawings of Rembrandt* II, 1954, no. 443; *Rembrandt Drawings from American Collections*, no. 9; Paris, no. 122; Cincinnati, no. 268; J. Gantner, *Rembrandt und die Verwandlung Klassischer Formen*, Bern, 1964, pp. 27–51; K. Clark, *Rembrandt and the Italian Renaissance*, New York, 1968, pp. 53–56; *Rembrandt after Three Hundred Years*, no. 100; O. Benesch, *The Drawings of Rembrandt* II, 1973, no. 443.

This "profound and magisterial drawing" is one of the best demonstrations of Rembrandt's debt to the art of the Italian Renaissance. It is also a highly personal document of the process of the transformation and incorporation of Renaissance ideas into the artist's graphic oeuvre. Since he had never been to Italy, Rembrandt used a Lombard engraving of Leonardo's fresco in Santa Maria delle Grazie in Milan. The study consists of two stages. The first, in hard chalk, is probably from the middle 1630s. The second stage, in broader strokes and with softer chalk, was probably added in the late 1640s or early 50s. Rembrandt's interest in the Last Supper is reflected in later versions of this drawing, one in Berlin and another in the British Museum (C. White, *The Drawings of Rembrandt*, London, The British Museum, 1962, pp. 12–13).

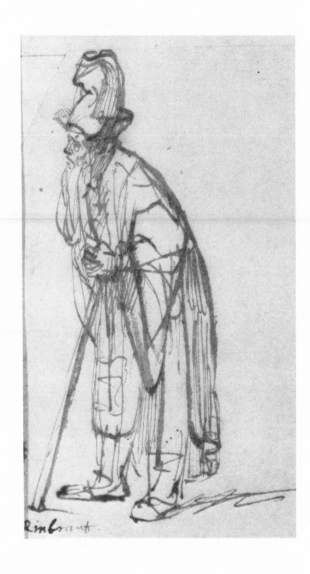

REMBRANDT HARMENSZ VAN RIJN, Dutch, Leyden, Amsterdam, 1606–1669

24. *Old Man Leaning on a Stick*

Pen and brown ink on paper, 13.4 × 8 cm. Inscribed by a later hand in lower right corner: *Rimbrant*

BIBLIOGRAPHY: O. Benesch, *The Drawings of Rembrandt* II, 1954, no. 260; *Rembrandt Drawings from American Collections*, 1960, no. 18; O. Benesch, *The Drawings of Rembrandt* II, 1973, no. 260.

This expressive drawing belongs to a series of studies representing old men and women leaning on sticks or staffs. Most of them are dated to between 1633 and 1635.

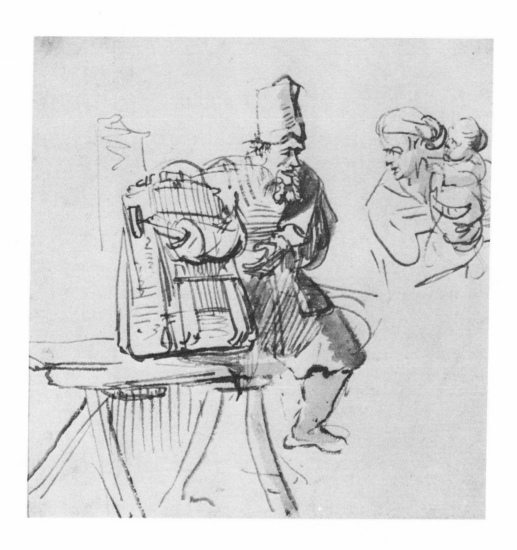

REMBRANDT HARMENSZ VAN RIJN, Dutch, Leyden, Amsterdam, 1606–1669

25a. Peddler with a Knapsack and Woman Holding a Child

Pen and bister with sepia washes added by a later hand on paper, 12.9 × 12.5 cm. On the verso: No. 25b.

BIBLIOGRAPHY: W. R. Valentiner, "Komödiantendarstellungen Rembrandts," *Zeitschrift für Bildende Kunst* 59 (1925–26), pp. 272–275; O. Benesch, *The Drawings of Rembrandt* II, 1954, no. 419; O. Benesch, *The Drawings of Rembrandt* II, 1973, no. 419; *Tricolour,* no. 21.

According to Benesch, this drawing is from the artist's early years in Amsterdam, about 1637. It probably represents a peddler displaying his merchandise, which might be a rattrap.

REMBRANDT HARMENSZ VAN RIJN, Dutch, Leyden, Amsterdam, 1606–1669

25b. *Head and Bust of an Old Woman and Unidentified Object*

Pen and bister, 12.9 × 12.5 cm. Inscribed in pencil by a late nineteenth-century hand: *S. H. Yes.* Verso of No. 25a.

BIBLIOGRAPHY: W. R. Valentiner, "Komödiantendarstellungen Rembrandts," *Zeitschrift für Bildende Kunst* 59 (1925–26), pp. 272–275; O. Benesch, *The Drawings of Rembrandt* II, 1954, no. 419; O. Benesch, *The Drawings of Rembrandt* II, 1973, no. 419; *Tricolour,* no. 21.

The unidentified object might be the same rattrap represented on the recto, and the old woman another spectator around the same peddler.

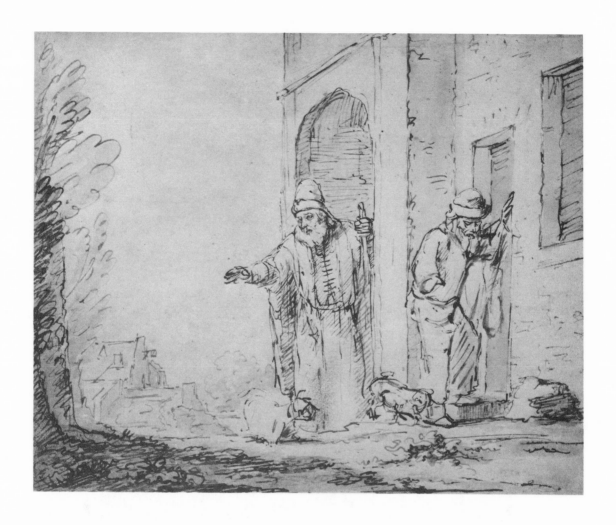

REMBRANDT HARMENSZ VAN RIJN, Dutch, Leyden, Amsterdam, 1606–1669

26. *Two Studies for Blind Tobit*

Pen and ink on paper, 20.5 × 25.8 cm.

BIBLIOGRAPHY: A. H. Mayor, "Rembrandt and the Bible," *The Metropolitan Museum of Art Bulletin*, Winter 1978/79, p. 10.

Rembrandt represented the episodes of the Book of Tobit many times throughout his life (J. S. Held, "Rembrandt and the Book of Tobit," *Gehenna Essays in Art* II, Northampton, Mass., 1964). In this drawing the seriousness of the story and genre-like details, like the little dog directing Tobias's step, are very successfully combined.

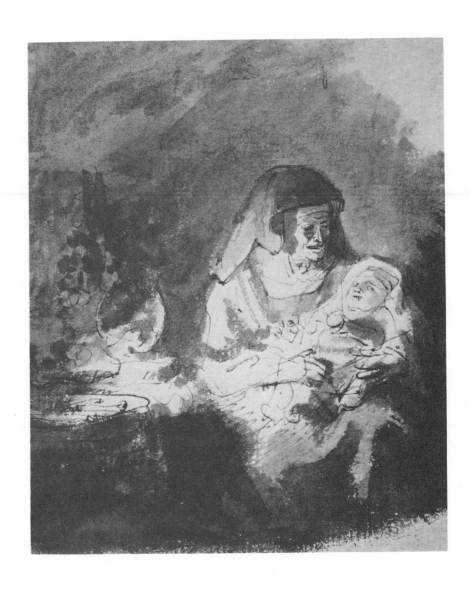

REMBRANDT HARMENSZ VAN RIJN, Dutch, Leyden, Amsterdam, 1606–1669

27. *Old Woman with a Baby in Her Arms*

Pen and bister with sepia washes on paper, 13.8 × 11.6 cm.

BIBLIOGRAPHY: *R. Kann Collection*, no. 167; O. Benesch, *The Drawings of Rembrandt* IV, 1955, no. 742; J. G. van Gelder, "The Drawings of Rembrandt," *The Burlington Magazine* 103 (1961), p. 51; O. Benesch, *The Drawings of Rembrandt* IV, 1973, no. 742; *Tricolour*, no. 24.

The attribution to Rembrandt is questioned by several experts. However, O. Benesch accepts it as by the master and comments on "the undulating play of lines in the delicately drawn figure group" and the "advanced treatment of light" in the drawing.

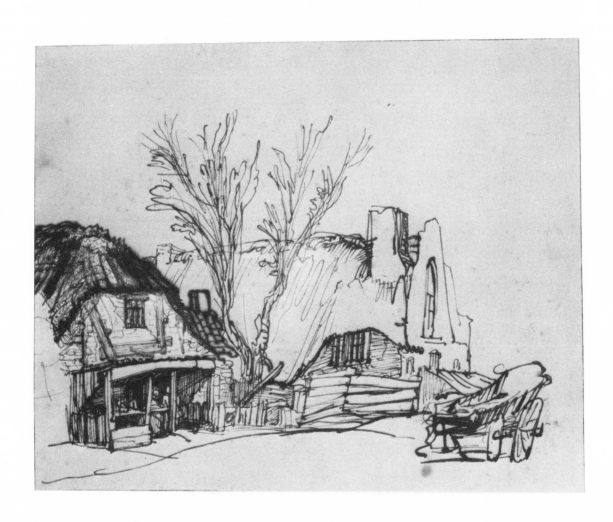

REMBRANDT HARMENSZ VAN RIJN, Dutch, Leyden, Amsterdam, 1606–1669

28. *Two Cottages*

Pen and dark brown ink with white paint and gallnut ink on paper, 14.9 × 19.2 cm.

BIBLIOGRAPHY: O. Benesch, *The Drawings of Rembrandt* II, 1954, no. 462a; *Rembrandt after Three Hundred Years*, no. 114; O. Benesch, *The Drawings of Rembrandt* II, 1973, no. 462a.

This powerful drawing is one of the many sketches Rembrandt made around Amsterdam. Like the artist's other similar studies of farm buildings, it probably dates from 1640–1645.

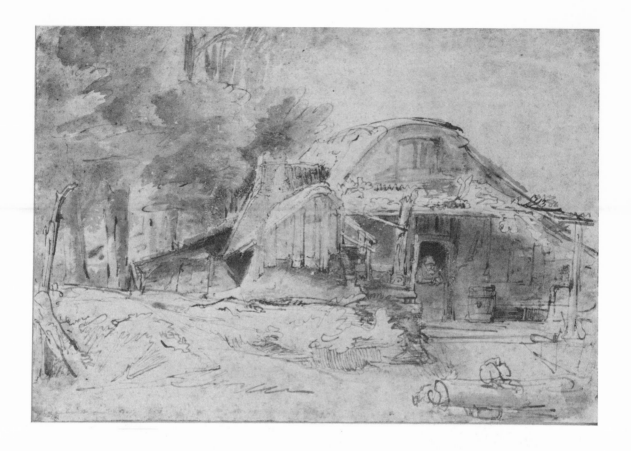

REMBRANDT HARMENSZ VAN RIJN, Dutch, Leyden, Amsterdam, 1606–1669

29. Cottage near the Entrance to a Wood

Pen and brown ink and brown wash on paper, 29.8 × 45.2 cm. Signed and dated in pen and brown ink in lower left corner: *Rembrandt f. 1644.*

BIBLIOGRAPHY: J. P. Heseltine, *Original Drawings by Rembrandt in the Collection of J. P. H.*, London, 1907; M. Eisler, *Rembrandt als Landschafter,* Munich, 1918, p. 65; C. de Tolnay, *History and Technique of Old Master Drawings*, New York, 1943, no. 197; O. Benesch, *The Drawings of Rembrandt* IV, 1955, no. 815; Paris, no. 123; Cincinnati, no. 26; *Rembrandt Drawings from American Collections,* no. 40; *Rembrandt after Three Hundred Years*, no. 117; O. Benesch, *The Drawings of Rembrandt* IV, 1973, no. 815; Guidebook, pp. 188–189.

This is one of the most important landscape drawings by Rembrandt for many reasons. It is his largest and one of the very few signed and dated by him. More importantly, as O. Benesch remarks, "it is a drawing as its own end drawn from nature." Lambert Doomer also made a sketch of the same cottage (Louvre, Paris). It has been suggested that the two artists may have done these drawings at the same time (see J. Q. van Regteren Altena, *Mostra di incisioni e disegni di Rembrandt*, Rome-Florence, 1951, no. 77).

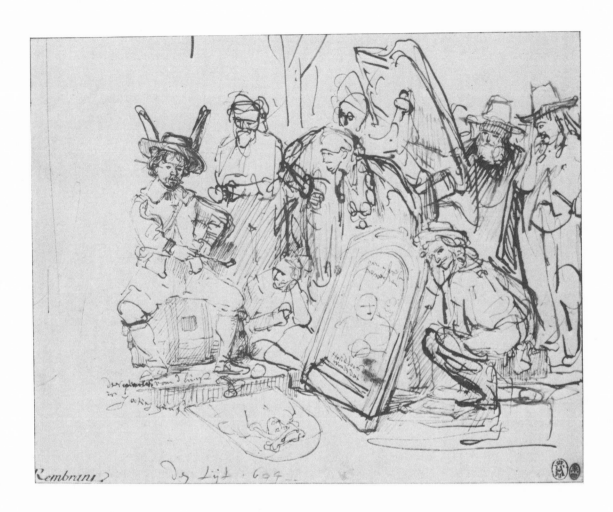

REMBRANDT HARMENSZ VAN RIJN, Dutch, Leyden, Amsterdam, 1606–1669

30. *Satire on Art Criticism*

Pen and brown ink, 15.6 × 20 cm. Inscribed and dated in lower center: *den tyt 1644*. Further inscriptions in the artist's hand on the platform of the critic: *dees...van d kunst / is .ooting gunst;* on the framed painting:... / ...*and Houdlos... / i ind. dat.* Inscribed by a later hand in lower left corner: *Rembrandt*.

BIBLIOGRAPHY: C. Hofstede de Groot, *Die Handzeichnungen Rembrandts*, Haarlem, 1906, no. 303; O. Benesch, *The Drawings of Rembrandt* IV, 1955, no. A35a; *Rembrandt Drawings from American Collections*, no. 41; *Rembrandt after Three Hundred Years*, no. 115; O. Benesch, *The Drawings of Rembrandt* IV, 1973, no. A35a.

Although neither the exact reading of the inscriptions nor the full meaning of the figures represented is known, this spirited drawing is a clear satire on the art critics of Rembrandt's time. The unusual subject and style may be the reason that some scholars of Rembrandt doubt the attribution. E. Haverkamp-Begemann and others, however, believe that these claims are unjustified. J. Rosenberg calls it a "crisp and lively drawing which is obviously a biting caricature of the contemporary type of art critic."

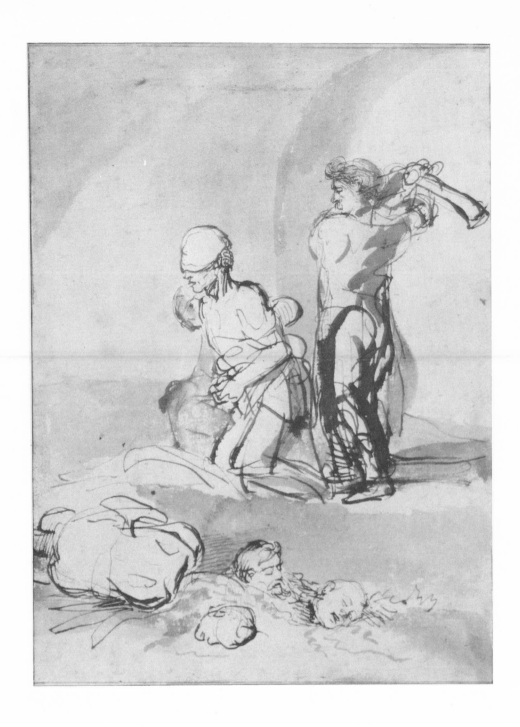

REMBRANDT HARMENSZ VAN RIJN, Dutch, Leyden, Amsterdam, 1606–1669

31. *Beheading of Prisoners*

Pen and ink with ink and China ink washes on paper, 18 × 13.2 cm.

BIBLIOGRAPHY: O. Benesch, *A Catalogue of Rembrandt's Selected Drawings*, London, 1947, no. 109; O. Benesch, *The Drawings of Rembrandt* III, 1954, no. 478; O. Benesch, *The Drawings of Rembrandt* III, 1973, no. 478; N. Konstám, "Rembrandt's Use of Models and Mirrors," *The Burlington Magazine* 119 (1977), pp. 94–98, fig. 35.

The gruesome subject of this beautifully preserved drawing is sometimes connected with the beheading of St. John the Baptist. O. Benesch also suggests that it might represent the beheading of the Tarquinian conspirators.

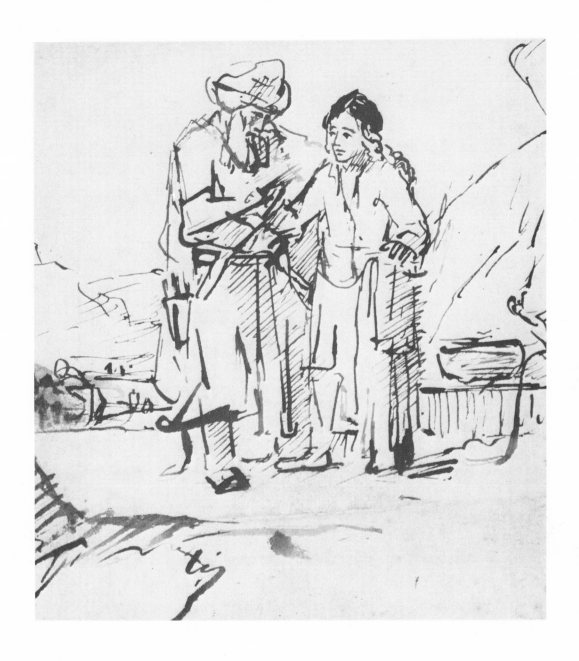

REMBRANDT HARMENSZ VAN RIJN, Dutch, Leyden, Amsterdam, 1606–1669

32. *Abraham and Isaac Before the Sacrifice*

Pen and ink on paper, 15 × 13.2 cm.

BIBLIOGRAPHY: W. R. Valentiner, *Die Handzeichnungen Rembrandts* I (Klassiker der Kunst, vols. 31, 32), New York, 1925–1934, p. 50, fig. 47.

Valentiner dates this drawing to about 1652 and remarks that it is "a very impressive composition with the expression of the youth, reminiscent of Titus, particularly well rendered."

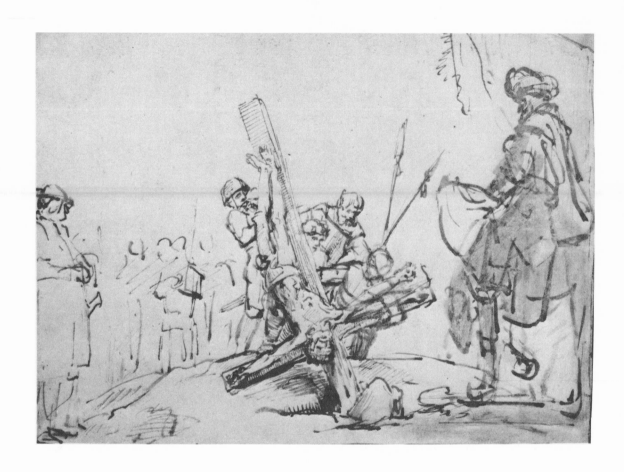

REMBRANDT HARMENSZ VAN RIJN, Dutch, Leyden, Amsterdam, 1606–1669

33. *The Crucifixion of St. Peter*

Pen and ink with white paint on paper, 20 × 26.9 cm.

BIBLIOGRAPHY: W. R. Valentiner, *Die Handzeichnungen Rembrandts* II (Klassiker der Kunst, vols. 31, 32) New York, 1925–1934, p. 107, fig. 549; O. Benesch, *The Drawings of Rembrandt* VI, 1957, no. C102; O. Benesch, *The Drawings of Rembrandt* VI, 1973, no. C102.

Opinions on the attribution and dating of this drawing are still divided. Valentiner accepts it as by the hand of Rembrandt and dates it to about 1653. Benesch maintains in both catalogues that this is a copy of an unknown original from about 1660.

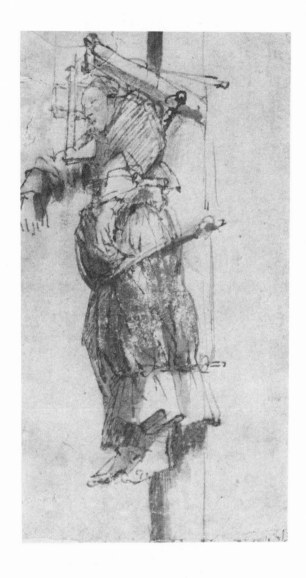

REMBRANDT HARMENSZ VAN RIJN, Dutch, Leyden, Amsterdam, 1606–1669

34. *Woman Hanging on the Gallows*

Pen and brown ink with wash on brownish paper, 14.2 × 8.1 cm.

BIBLIOGRAPHY: *R. Kann Collection*, no. 169; O. Benesch, *The Drawings of Rembrandt* V, 1957, no. 1106; *Rembrandt Drawings from American Collections*, no. 65; O. Benesch, *The Drawings of Rembrandt* V, 1973, no. 1106; I. H. van Eeghen, "Elsje Christiaens en de kunsthistorici," *Amstelodamum* 61 (1969), pp. 73–78.

The woman so cruelly punished was a Dane named Elsje Christiaens. She was sentenced to death on May 1, 1664; Rembrandt must have done the drawing shortly afterward. Another sketch by him showing the same woman from a different view was given to the Museum by Mrs. H. O. Havemeyer (W. R. Valentiner, "Rembrandt Drawings in the Havemeyer Collection," *Metropolitan Museum Studies* 3 (1930–1931), p. 143).

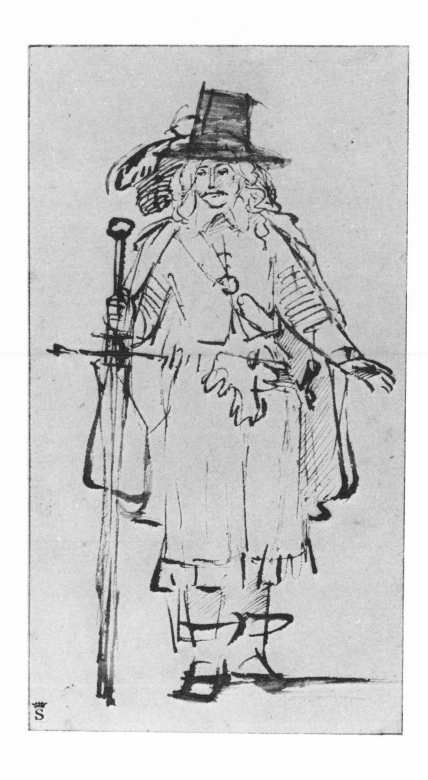

REMBRANDT HARMENSZ VAN RIJN, Dutch, Leyden, Amsterdam, 1606–1669

35. *Man with a Sword*

Pen and brown ink with wash on paper, 20 × 11 cm.

BIBLIOGRAPHY: C. Hofstede de Groot, *Die Handzeichnungen Rembrandts*, Haarlem, 1906, no. 800; *R. Kann Collection*, no. 166; S. Slive, *Drawings of Rembrandt* II, New York, 1965, no. 365; *Tricolour*, no. 23.

Hofstede de Groot dates the drawing to about 1650, mostly on the basis of the costume. Slive remarks that it might be by a good pupil's hand and suggests that "though the graphic vocabulary is quite close to the one Rembrandt used around 1650–1655, the summary strokes lack the rich pictorial glow characteristic of the master's drawings of this phase."

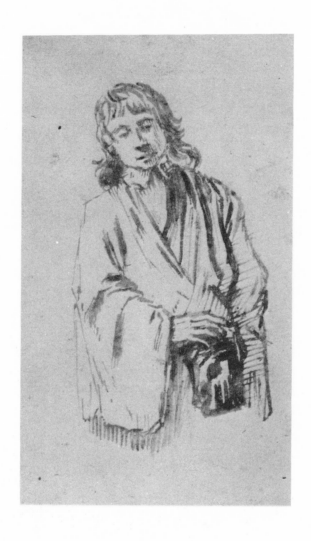

SCHOOL OF REMBRANDT HARMENSZ VAN RIJN, Dutch, Leyden, Amsterdam, 1606–1669

36a. *A Young Man*

India ink and pen on paper, 15 × 12.4 cm. On the verso: No. 36b.

BIBLIOGRAPHY: Christie & Manson, *A Catalogue of the very celebrated collection of painter's etchings of William Seguier, Esq.*, London, April 1844, no. 591; *R. Kann Collection*, no. 170.

The sketch is drawn on an effaced proof of an etching by Jan Lievens (No. 36b.)

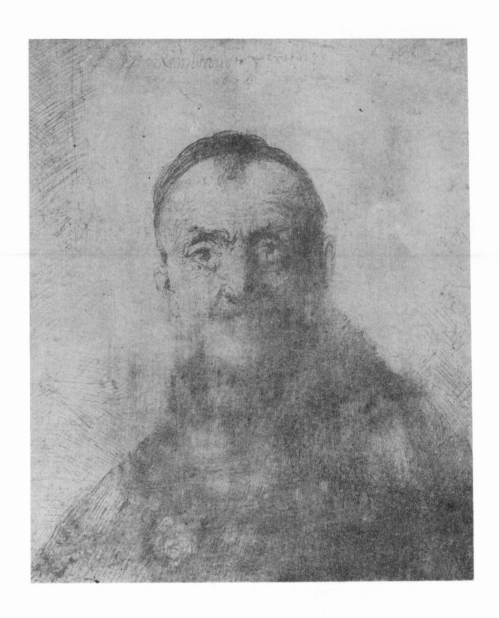

JAN LIEVENS, Dutch, Leyden, Amsterdam, 1607–1674

36b. *The First Oriental Head*

Engraving with drypoint, 15 × 12.4 cm. Signed and dated in upper center: *Rembrandt geretuc 1635.*
Defaced. Verso of No. 36a.

BIBLIOGRAPHY: Christie & Manson, *A Catalogue of the very celebrated collection of painter's etchings of
William Seguier, Esq.*, London, April 1844, no. 591; *R. Kann Collection*, no. 170.

The inscription, with its reference to "retouching," seems to indicate that Rembrandt was
only partially responsible for this etching, which might be by Lievens or a copy after one of
his works. The person represented has also been called Rembrandt's father (A. M. Hind,
"The Portraits of Rembrandt's Father," *The Burlington Magazine* 8 (1905), pp. 426–427).

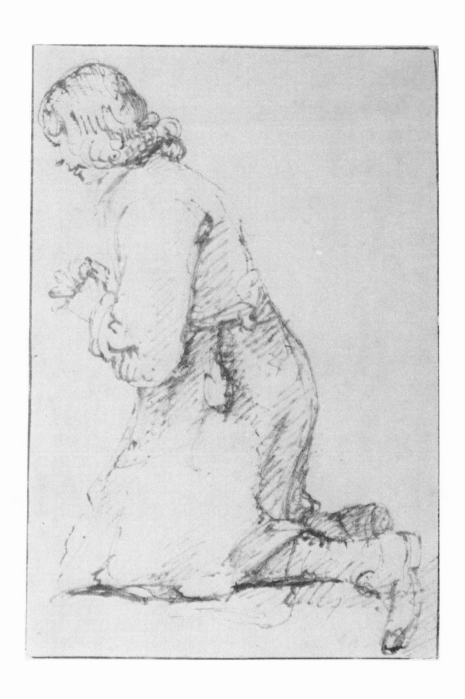

SCHOOL OF REMBRANDT HARMENSZ VAN RIJN, Dutch, Leyden, Amsterdam,
1606–1669

37. *A Praying Youth*

Pen and brown ink on paper, 15.2 × 10.3 cm.

BIBLIOGRAPHY: C. G. Boerner, *Handzeichnungs-Sammlung des Dr. C. Hofstede de Groot*, Leipzig,
November 1931, no. 172, ill.

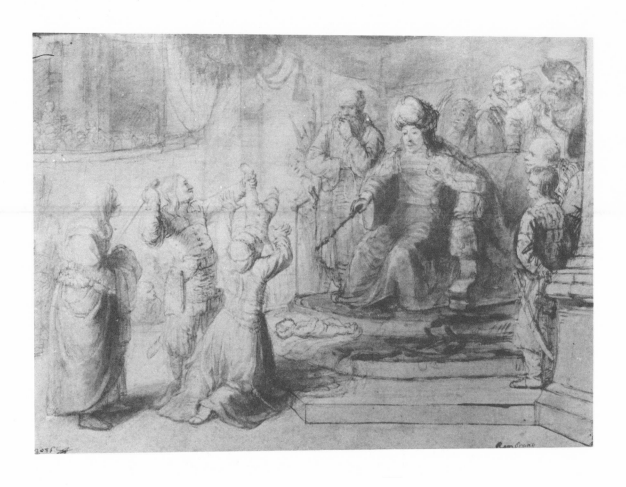

CONSTANTIJN DANIEL RENESSE, Dutch, Maarsen by Utrecht, Leyden, Eindhoven, 1626–1680

38. *The Judgment of Solomon*

Black chalk, pen, and ink with brown wash and traces of body-color on paper, 23.1 × 32.7 cm. Initialed and numbered in ink in lower left corner: *2086*. Old inscription in lower right corner: *Rembrant*. Inscribed in ink on the verso: *Tweede ordinatie By Rombrant 1649*.

BIBLIOGRAPHY: J. Byam Shaw, "Three Drawings of Rembrandt's School," *Old Master Drawings* 13 (1938), p. 20, ill.; *Tricolour*, no. 25.

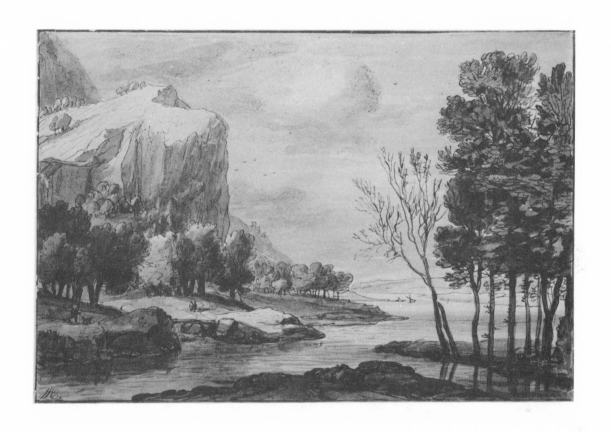

ROELAND ROGHMAN, Dutch, Amsterdam, about 1620–1686

39. *River Landscape with Rocky Cliff*

Pen and ink with wash on paper, 15.2 × 23.1 cm. Signed in pen and ink in lower right corner: *R Roghman*.

BIBLIOGRAPHY: *Tricolour,* no. 27.

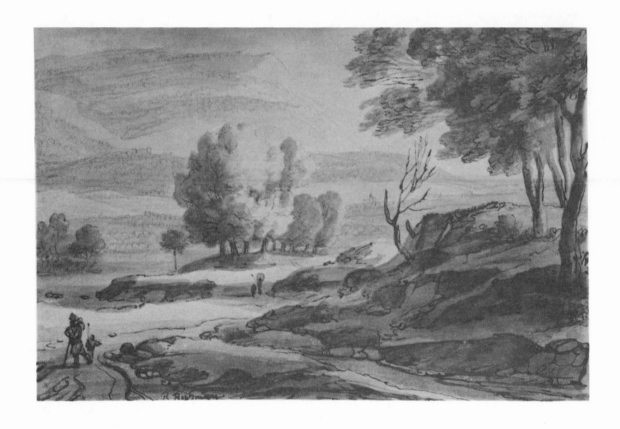

ROELAND ROGHMAN, Dutch, Amsterdam, about 1620–1686

40. *Mountainous River Landscape with Figures*

Black chalk, pen and ink, and gray wash on paper, 15.6 × 23.5 cm. Signed in ink in lower left margin: *R. Roghman*.

BIBLIOGRAPHY: F. Muller & Co., *Sammlung C. Hofstede de Groot Auktionskatalog*, Berlin, May 1913; Sotheby & Co., *The Sale of the H. S. Reitlinger Collection, Part VII*, London, June 1954, lot. 694; *Tricolour*, no. 26.

The wide-sweeping landscape clearly shows the influence of the artist's Italian journey around 1640.

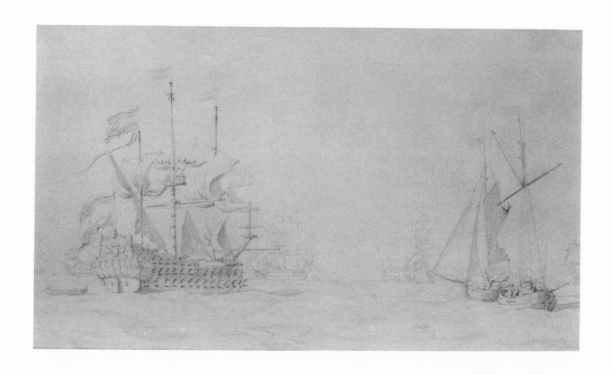

WILLEM VAN DE VELDE THE ELDER, Dutch, Leyden, Amsterdam, London, 1611–1693

41. *A Fleet Sailing out to Sea*

Black chalk and gray wash on paper, 23.9 × 42.2 cm.

BIBLIOGRAPHY: *Tricolour,* no. 28.

This drawing probably represents a scene from the beginning of the "Four Days' Battle" on Friday, June 11, 1666. It was fought between the Dutch under Admiral de Ruyter and the English under the Duke of Albemarle and Prince Rupert. On the left is the "Delft," the Dutch ship under Rear Admiral J. van Nes.

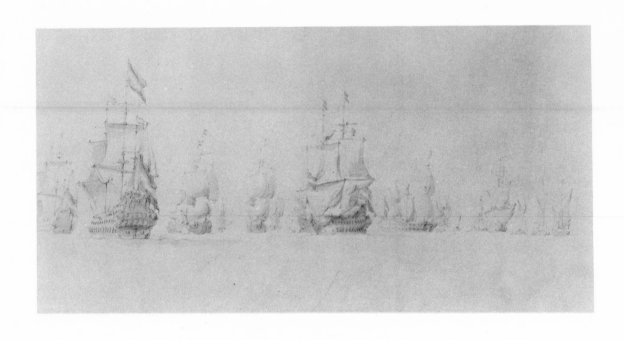

WILLEM VAN DE VELDE THE ELDER, Dutch, Leyden, Amsterdam, London,
1611–1693

42. *Saturday the 12th of June, 1666*

Black chalk with gray wash on paper, 26.6 × 53.2 cm.

BIBLIOGRAPHY: *Tricolour,* no. 29.

This broad view represents an episode of the second day of the "Four Days' Battle," the
beginning of which is shown on the previous drawing (No. 41).

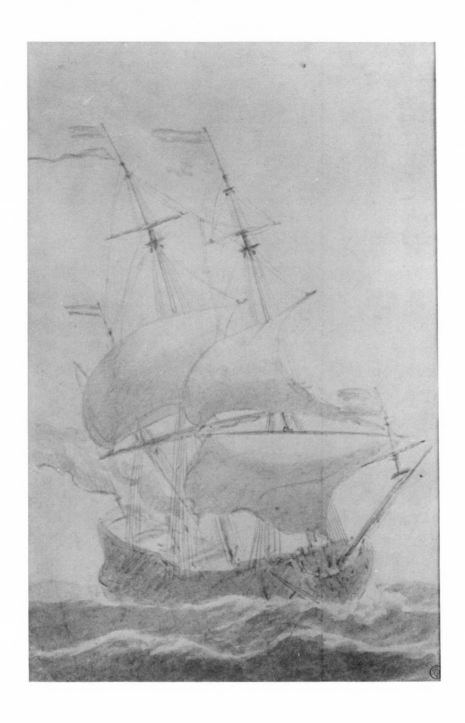

WILLEM VAN DE VELDE THE ELDER, Dutch, Leyden, Amsterdam, London, 1611–1693

43. *Man o' War Tacking Windward in a Storm*

Black chalk with gray wash on paper, 30.1 × 20 cm.

BIBLIOGRAPHY: *Tricolour,* no. 31.

This drawing and the previous one might have been included in the sale of the drawings removed from Warwick Castle in 1936 (Sotheby & Co., *Catalogue of Important Drawings by the Old Masters and Masters of the English School Removed from Warwick Castle and Sold by the Order of the Rt. Hon. The Earl of Warwick and of the Trustees of the late (6th) Earl of Warwick,* London, 1936). For the time being it is impossible to identify these two among the more than fifty van de Velde drawings in the sale. However, they might have been included in lot 121, which contained "various studies of ships at sea. Black chalk and wash and seven others."

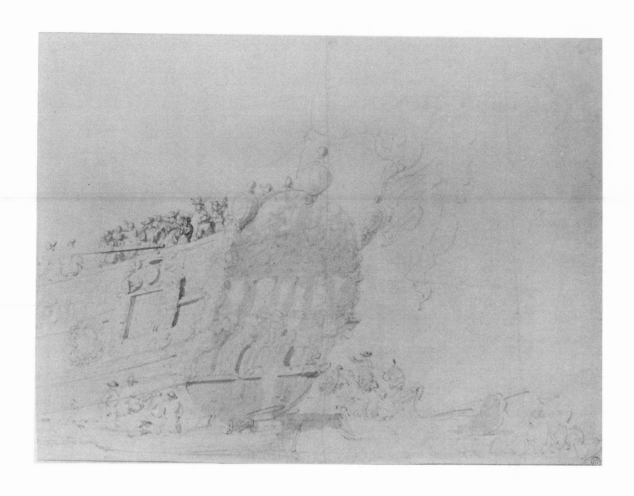

WILLEM VAN DE VELDE THE ELDER, Dutch, Leyden, Amsterdam, London, 1611–1693

44. *The Stern of the Royal Yacht ''Katherine''*

Black chalk with gray wash on paper, 27.5 × 38 cm.

BIBLIOGRAPHY: *Tricolour,* no. 30.

This free drawing shows the stern of the royal yacht, probably on the occasion of its return in 1674 by the Dutch, who had captured it in 1673. The drawing must have been made in England since the artist had been there since 1672.

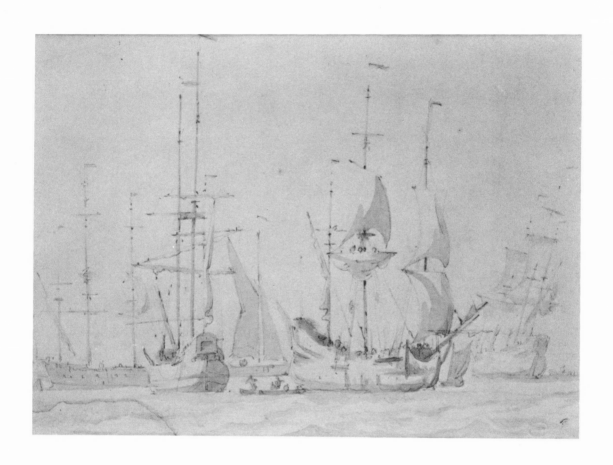

WILLEM VAN DE VELDE THE YOUNGER, Dutch, Leyden, Amsterdam, London,
1633–1707

45. *Types of Dutch Shipping*

Black chalk with light brown wash on paper, 16.5 × 22.8 cm.

BIBLIOGRAPHY: *Tricolour,* no. 32.

An interesting group of sailing ships lying in harbor. Since they are all Dutch-type vessels, it
may be assumed that the drawing was made before 1673, when the artist, together with his
father, Willem van de Velde the Elder, entered the service of Charles II, king of England.

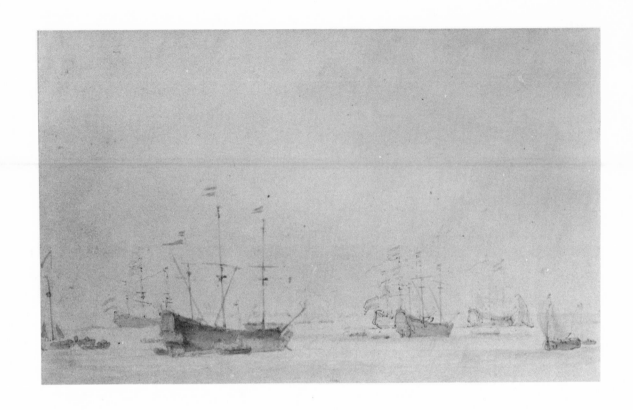

WILLEM VAN DE VELDE THE YOUNGER, Dutch, Leyden, Amsterdam, London,
1633–1707
46. *Five Ships at Anchor*
Pen and brown ink with gray wash on paper, 18.2 × 28.7 cm.
BIBLIOGRAPHY: *Tricolour,* no. 33.

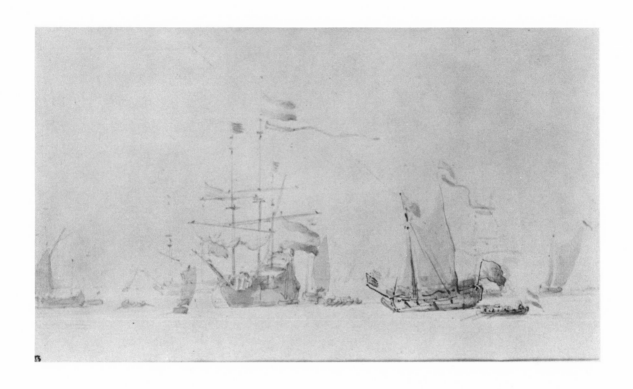

WILLEM VAN DE VELDE THE YOUNGER, Dutch, Leyden, Amsterdam, London,
1633–1707
47. *Ships in Harbor*
Black chalk and ink with gray wash on paper; 15.3 × 26.2 cm.
Unpublished.

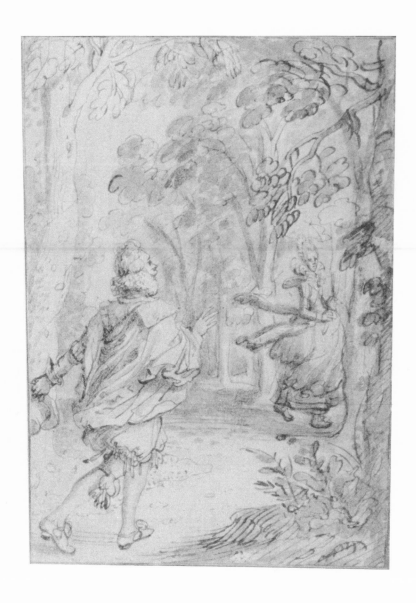

DAVID VINCKBOONS, Flemish-Dutch, Mechelen, Antwerp, Amsterdam, Leeuwarden, 1576–1629

48. *Young Couple as Apollo and Daphne in the Woods*

Pen and ink with blue and brown washes on paper, 12.1 × 8.2 cm.

BIBLIOGRAPHY: Sotheby & Co., *The Sale of the H. S. Reitlinger Collection, Part VII*, London, June 1954, lot 799; *Tricolour*, no. 35.

The style of the drawing is very close to that of other works by the artist representing banquets and the story of the prodigal son, all dated to between 1605–1610 (cf. K. Goossens, *David Vinckboons*, Antwerpen-'s-Gravenhage, 1954, pp. 91–95).

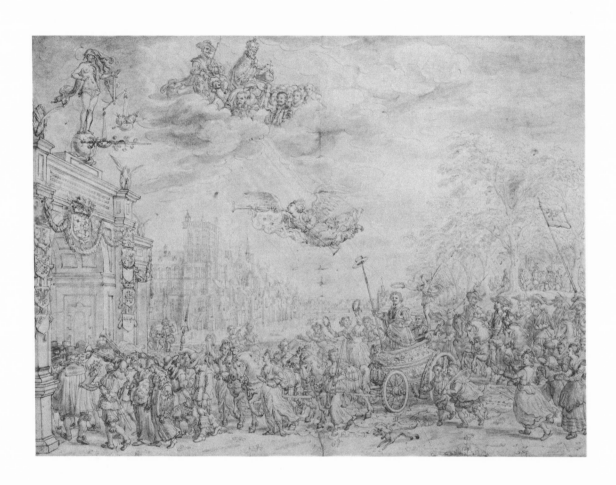

DAVID VINCKBOONS, Flemish-Dutch, Mechelen, Antwerp, Amsterdam, Leeuwarden, 1576–1629

49. *The Triumphal Entry of Frederik Hendrik of Orange into The Hague*

Pen and ink with blue and gray washes on paper, 26.8 × 50.8 cm. Signed in lower left: *Vinkebons*.

BIBLIOGRAPHY: J. S. Held, "Notes on David Vinckeboons," *Oud-Holland*, 66 (1951), pp. 241–244; K. Goossens, *David Vinckboons*, Antwerpen-'s-Gravenhage, 1954, p. 5; *Tricolour*, no. 34.

This ambitious drawing represents the triumphal entry of Prince Frederik Hendrik of Orange into The Hague after the successful sieges of Wesel and 's-Hertogenbosch in 1629. The large triumphal arch, topped by the figure of Justice-Fortune and decorated with the arms of the prince, was a temporary structure erected for the occasion. In the background is a view of the buildings of the Buitenhof. This is probably one of the most elaborate drawings known by the artist and was most likely his last.

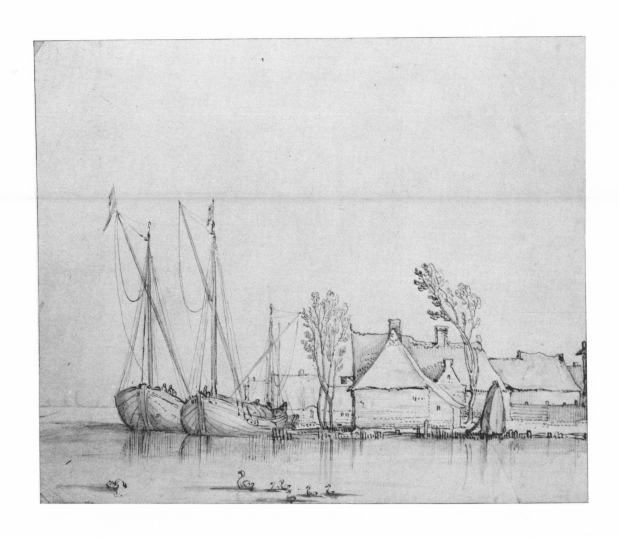

CLAES JANSZ VISSCHER, Dutch, Amsterdam, about 1550–about 1612

50. *Barges Moored by Cottages*

Pen and wash on paper, 15.2 × 18.8 cm.

BIBLIOGRAPHY: *Tricolour,* no. 36.

It has been suggested that this drawing might be by the artist's son and collaborator, Claes Jansz Visscher the Younger, 1586–1652.

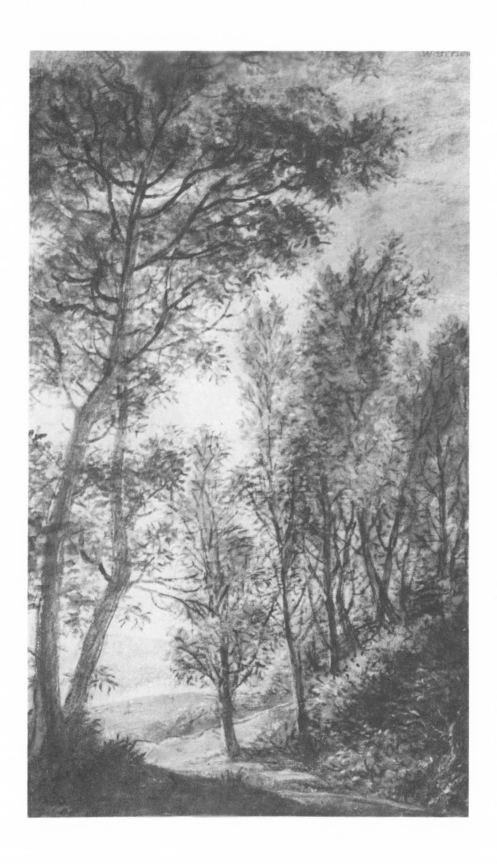

ANTOINE WATERLOO, Dutch, Lille, Amsterdam, Utrecht, about 1610–1690

51. *Wooded Landscape*
Black chalk with gray wash heightened with white on paper, 29.2 × 17.8 cm.
BIBLIOGRAPHY: Sotheby & Co., *The Sale of the H. S. Reitlinger Collection, Part VII*, London, June 1954, lot 743; *Tricolour,* no. 38.

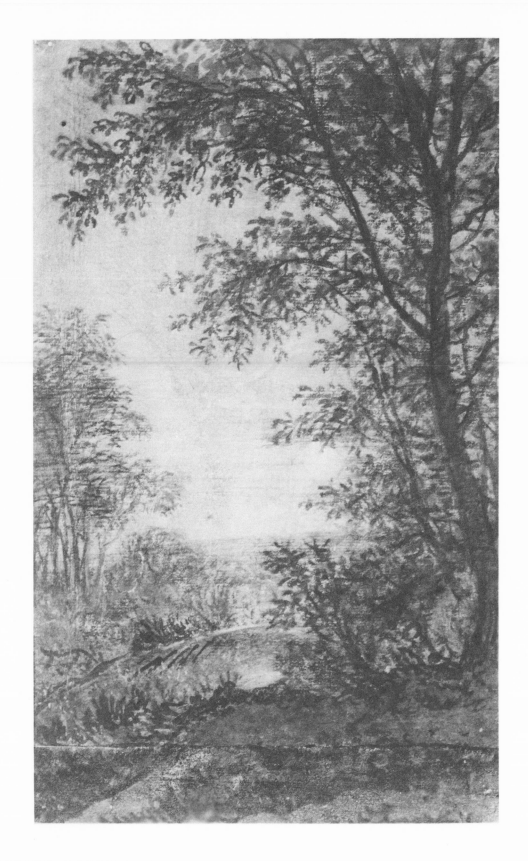

ANTOINE WATERLOO, Dutch, Lille, Amsterdam, Utrecht, about 1610–1690

52a. *Wooded Landscape*

Black chalk with gray wash heightened with white on paper, 32.7 × 17.8 cm. Inscribed in ink in upper right: *Waterlon*. On the verso: No. 52b.

BIBLIOGRAPHY: Sotheby & Co., *The Sale of the H. S. Reitlinger Collection, Part VII*, London, June 1954, lot 743; *Tricolour*, no. 37, ill.

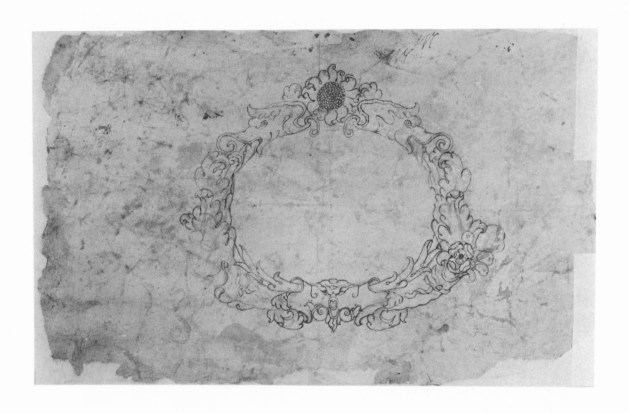

ANTOINE WATERLOO, Dutch, Lille, Amsterdam, Utrecht, about 1610–1690

52b. *Design for a Frame*

Black ink and pencil on paper, faint traces of pencil sketches, 17.8 × 32.7 cm. Verso of No. 52a.

BIBLIOGRAPHY: *Tricolour,* no. 37.

The artist's wife, Catharyn Stevens van den Dorpe, was the widow of the painter Elias Homis. She was also a dealer in pictures, and it is possible that this design was done in connection with her business.

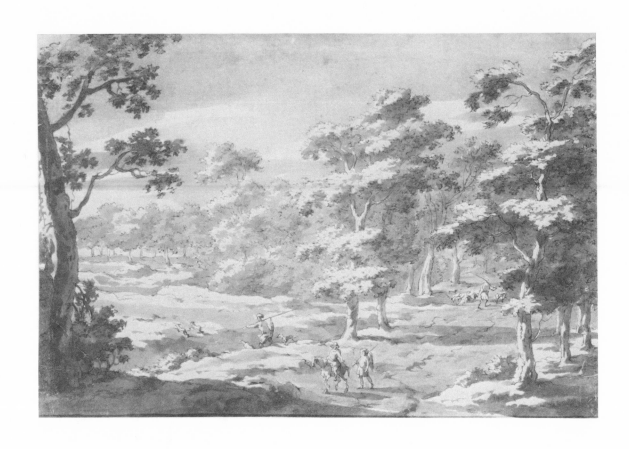

JAN FRANS VAN BLOEMEN, Flemish, Antwerp, Rome, 1662–1749

53. *Forest Clearing with Figures*

Pen and ink with wash on paper, 15.5 × 23.3 cm.

Unpublished.

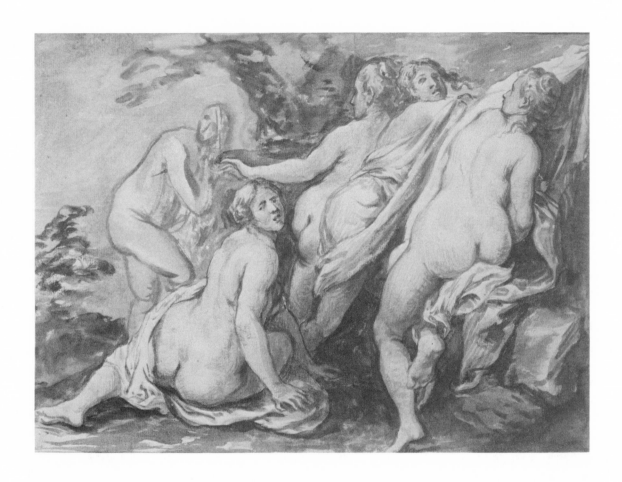

CASPAR DE CRAYER, Flemish, Antwerp, Brussels, Ghent, 1584–1669

54. *Nymphs Surprised*

Red chalk with washes of brown and India ink on paper, 20.2 × 27.7 cm.

BIBLIOGRAPHY: Oppenheimer sale, lot 225.

The artist is famous for his paintings and drawings of religious subjects. This drawing, with a mythological scene, is therefore considered rare (see E. van Terlaan, "Un grand artiste meconnu, Gaspard de Crayer," *Gazette des Beaux-Arts* 78 [1926], pp. 93–108).

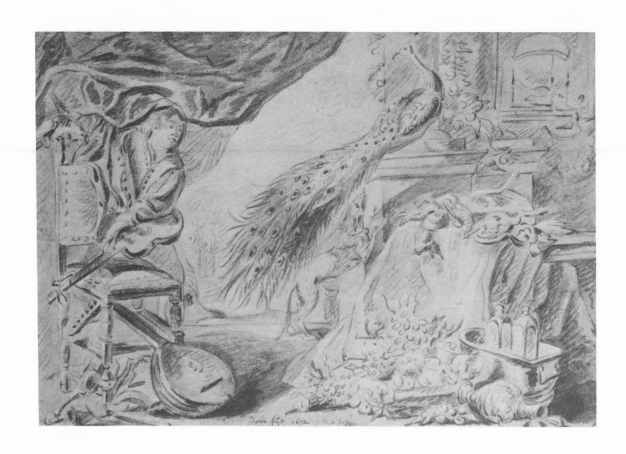

JAN FYT, Flemish, Antwerp, 1611–1661

55. *Studio Still Life with Peacock*

Black chalk, ink, and pen heightened with white paint on paper, 29.2 × 44.2 cm. Inscribed by a later hand in ink in bottom center, along with undecipherable letters and numbers: *Jan fyt 1672*.

Unpublished.

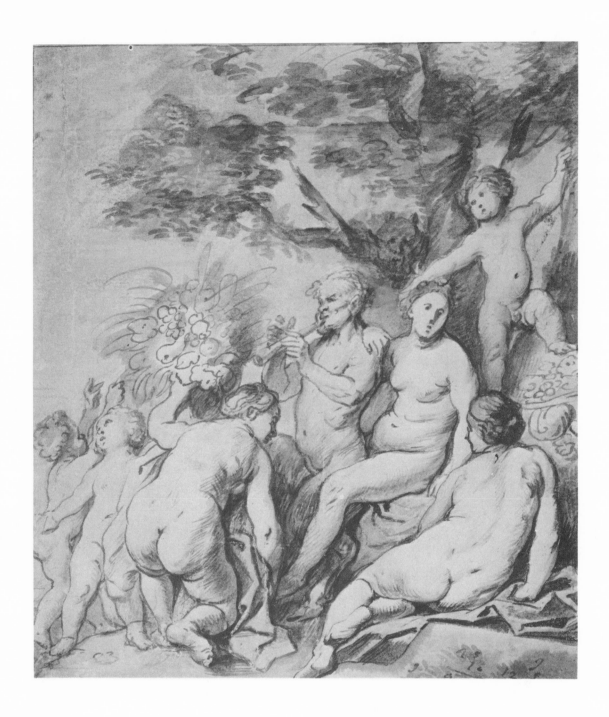

JACOB JORDAENS, Flemish, Antwerp, 1593–1678

56a. *Nymphs, Satyrs, and Children*

Black chalk, pen, and brush with brown ink and colored washes on paper; 23 × 20 cm. Numerical notations in lower right corner. On the verso: No. 56b.

BIBLIOGRAPHY: Mortimer Brandt Gallery, *Exhibition Jacob Jordaens*, New York, 1940, no. 13, ill.; Paris, no. 105; Cincinnati, no. 244; R. A. d'Hulst, *Tekeningen van Jacob Jordaens, 1593–1678*, exhibition catalogue, Antwerp, 1966, no. 55, ill.; M. Jaffé, *Jordaens*, no. 210, ill.

This elaborate drawing is probably a sketch for a painting, a representation of an allegory of fruitfulness.

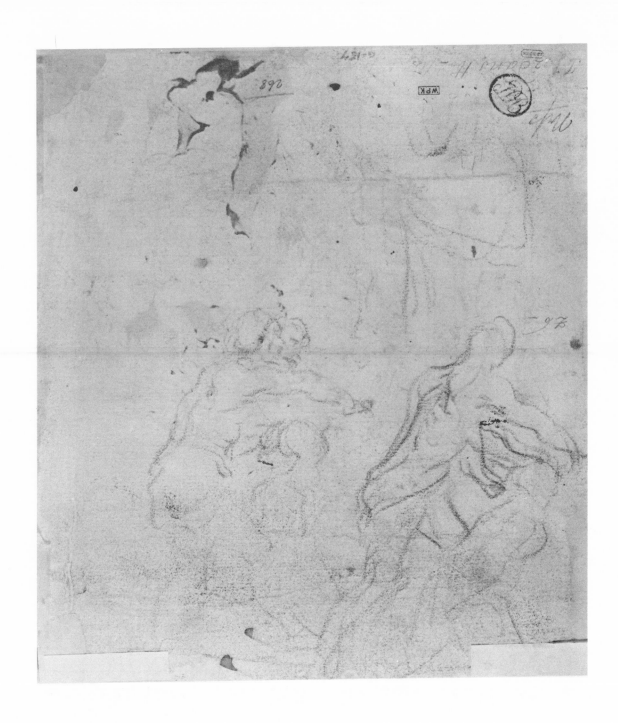

JACOB JORDAENS, Flemish, Antwerp, 1593–1678

56b. *Two Studies*

Black chalk on paper, 23 × 20 cm. Inscribed in pencil in upper right corner: *J. Jordans H.* Verso of No. 56a.

BIBLIOGRAPHY: Mortimer Brandt Gallery, *Exhibition Jacob Jordaens*, New York, 1940, no. 13, ill.; Paris, no. 105; Cincinnati, no. 244; R. A. d'Hulst, *Tekeningen van Jacob Jordaens, 1593–1678*, exhibition catalogue, Antwerp, 1966, no. 55, ill.; M. Jaffé, *Jordaens*, no. 210, ill.

The study on the left is probably for a martyrdom; the one on the right seems to represent two persons struggling.

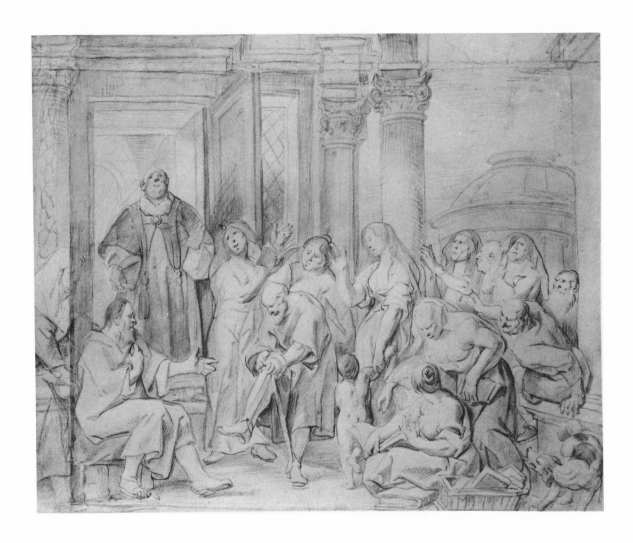

JACOB JORDAENS, Flemish, Antwerp, 1593–1678

57. *St. Peter Preaching to the Israelites in Solomon's Porch after Healing the Lame Man at the Beautiful Gate*

Red and black chalk reinforced with red ink and pen on paper, 35.5 × 43.2 cm. The paper is augmented at the top and on the left.

BIBLIOGRAPHY: R. A. d'Hulst, *Tekeningen van Jacob Jordaens, 1593–1678*, exhibition catalogue, Antwerp, 1966, no. 311; M. Jaffé, *Jordaens*, no. 259.

The scene is based on events described in Acts. The composition demonstrates Jordaens's admiration of Raphael's art, especially his designs for the Sistine Chapel tapestries. However, no tapestry or painting by the artist with this subject is known. M. Jaffé dates it to the late 1650s and remarks that "the drawing is the most intensely and eloquently Calvinist of Jordaens' compositions."

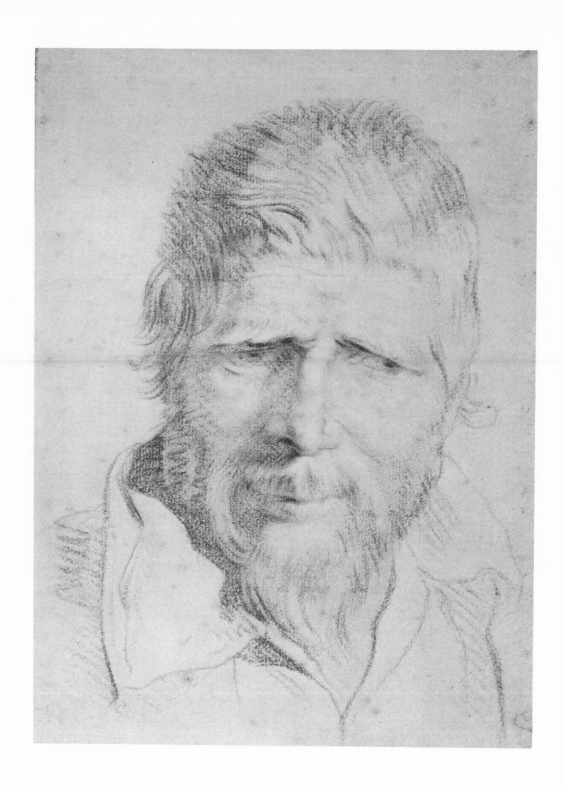

JACOB JORDAENS, Flemish, Antwerp, 1593–1678

58. *Head of a Man*

Black and red chalk on paper, 23.6 × 17.4 cm.

BIBLIOGRAPHY: Musées Royaux des Beaux-Arts de Belgique, *Exposition d'oeuvres de Jordaens et de son atelier,* Brussels, 1928, no. 143; Oppenheimer sale, lot 255c.

The bearded man is identified by an old pencil inscription on the verso as Baltasar Donner, or Doomer. There is no identical painted portrait in the artist's known oeuvre, and nothing further is known about the man. By comparing this work to Jordaens's other portrait drawings, we may date it to about 1650.

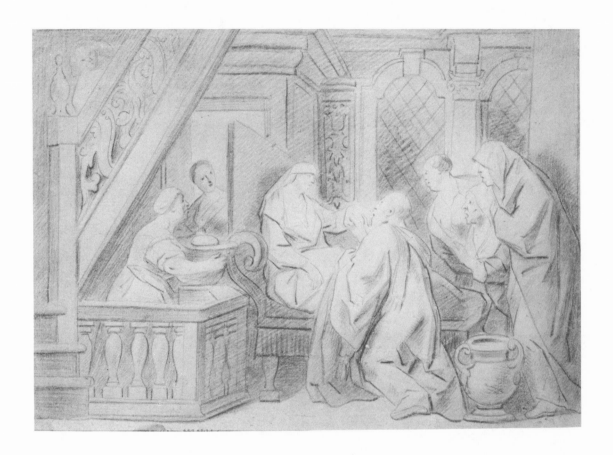

JACOB JORDAENS, Flemish, Antwerp, 1593–1678

59. *St. Peter Resuscitating Tabitha*

Red and black chalk with wash on a single sheet of paper, 30.1 × 40.3 cm. In the center of the lower margin is a badly rubbed red chalk inscription, undecipherable. Pen and ink inscription in lower left corner; *od myn*.

BIBLIOGRAPHY: Oppenheimer sale, lot 255a; Mortimer Brandt Gallery, *Exhibition Jacob Jordaens*, New York, 1940, no. 11, ill.

The subject of the drawing is described in Acts 9:39–40. An almost identical composition with the date 1670 (Museum of Châteauroux) places this drawing in the artist's last years. At this time he was one of the leaders of the Calvinists in Antwerp, and his religious beliefs are reflected in many compositions from this period (see No. 57).

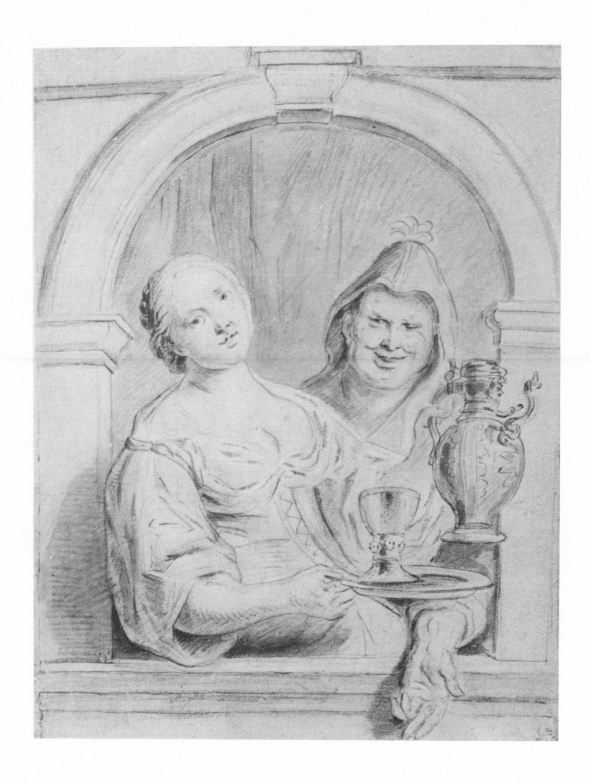

JACOB JORDAENS, Flemish, Antwerp, 1593–1678

60. *The Young Woman and the Fool*

Black, red, and white chalk with wash and ink on paper, 28 × 22 cm.

BIBLIOGRAPHY: Royal Academy of Art, *Exhibition of Flemish and Belgian Art 1300–1900*, London, 1927, no. 612; Mortimer Brandt Gallery, *Exhibition Jacob Jordaens*, New York, 1940, no. 15, ill.

Formerly called "The Merry Couple," this drawing belongs to a large group of allegorical compositions moralizing on the relationships of old fools and young girls (see M. Jaffé, *Jordaens*, nos. 68, 271, etc.). Although similar fat old fools appear in earlier paintings, this drawing is from the late 1660s. M. Jaffé remarks: "In old age Jordaens continued to recompound his memories of these motifs from his maturity" (M. Jaffé, *Jordaens*, p. 225).

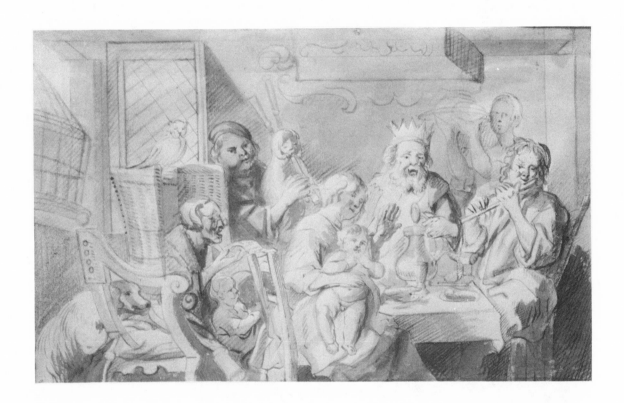

JACOB JORDAENS, Flemish, Antwerp, 1593–1678

61. *"The King Drinks"* (?)

Red and black chalk with blue, red, and gray washes on paper, 17.4 × 28.7 cm. Inscribed in lower left corner: *904*.

BIBLIOGRAPHY: Koninklijk Museum voor Schone Kunsten, *Tentoonstellung Jacob Jordaens*, exhibition catalogue, Antwerp, 1905, no. 122.

The weak composition seems to be a combination of the reduced version of the artist's famous drawing representing the Twelfth Night King (Antwerp, no. 843.) and another illustrating the proverb "As the Old Sing so the Young Twitter" (M. Jaffé, *Jordaens*, nos. 214, 216, 223). It is quite possible that the drawing was made by a studio member or by a student of the artist.

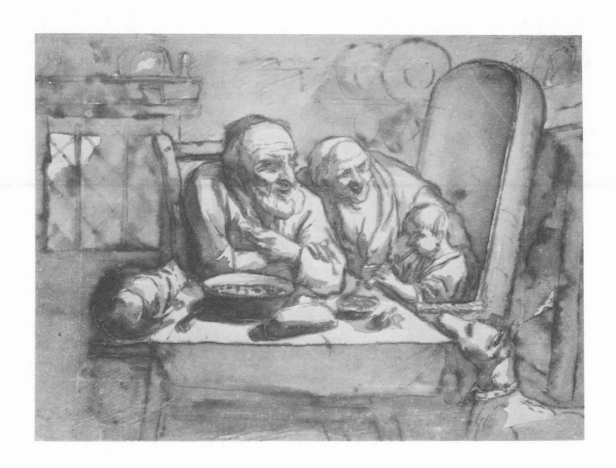

ATTRIBUTED TO JACOB JORDAENS, Flemish, Antwerp, 1593–1678

62. Old Couple with Child Playing the Pipe

Pen and brush with ink and washes on paper, 26.1 × 37 cm.

BIBLIOGRAPHY: Royal Academy of Art, *Exhibition of Flemish and Belgian Art 1300–1900*, London, 1927, no. 626; Oppenheimer sale, lot 256a.

This drawing is most likely by a pupil of the artist or a member of his studio.

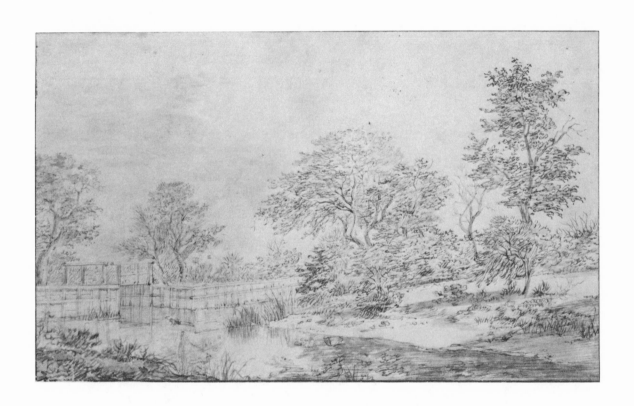

JAN VAN KESSEL, Flemish, Antwerp, 1626–1679

63a. *Landscape with Bridge*

Pen and ink with bluish gray wash on paper, 15.5 × 26.6 cm. Signed in lower left corner with connected initials *JK* and letter *F* (for "fecit"). On the verso: No. 63b.

Unpublished.

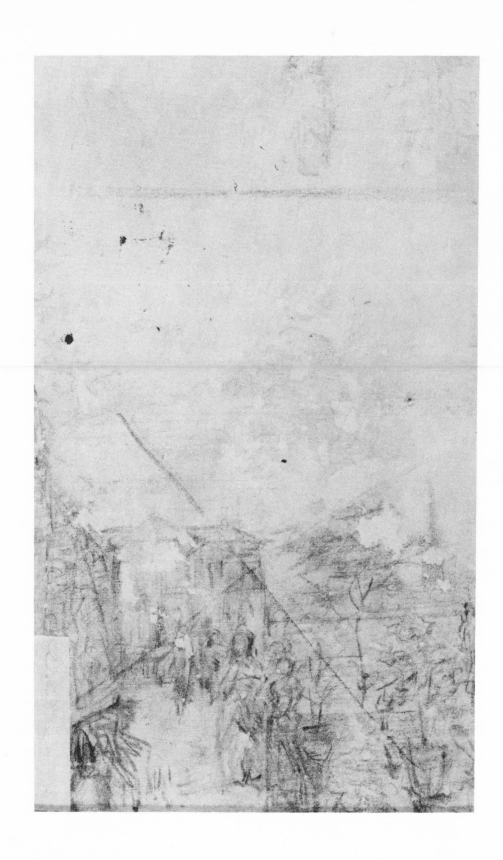

JAN VAN KESSEL, Flemish, Antwerp, 1626–1679

63b. *Garden Scene with Figures*

Black chalk on paper, 26.6 × 15.5 cm. Verso of No. 63a.

Unpublished.

The large "X" indicates that this is an abandoned study.

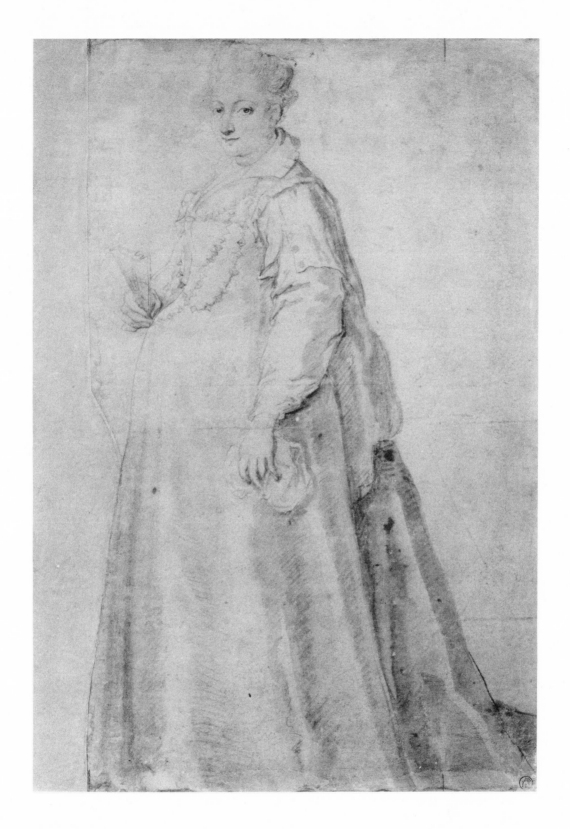

FRANS POURBUS THE YOUNGER, Flemish, Antwerp, Brussels, Mantua, Paris,
1569–1622

64. *Standing Lady*

Black and red chalk, pen and ink with wash on paper, 35.4 × 16.6 cm.

Unpublished.

Judging from the costume and jewelry of the figure, this drawing was inspired by the artist's
stay in France, where he was the court painter to Maria de' Medici from 1609 to 1622.

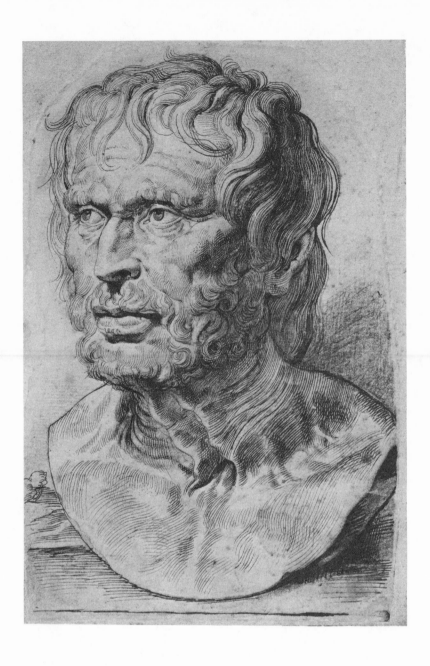

PETER PAUL RUBENS, Flemish, Siegen, Antwerp, Mantua, Rome, Antwerp, 1577–1640

65. *The So-called Bust of Seneca*

Black chalk, pen, and brown ink and brown wash on paper, 25.7 × 18 cm.

BIBLIOGRAPHY: M. Rooses, *L'oeuvre de P. P. Rubens; histoire et description de ses tableaux et dessins* V, Antwerp, 1886–1892, no. 1218; J.-A. Goris and J. S. Held, *Rubens in America*, Antwerp, 1947, no. 111; Paris, no. 127; Cincinnati, no. 243; Fogg Art Museum and Pierpont Morgan Library, *Drawings and Oil Sketches by Rubens from American Collections*, exhibition catalogue, Cambridge and New York, 1956, no. 13; Royal Museum of Fine Arts, *P. P. Rubens, Paintings-Oilsketches-Drawings*, exhibition catalogue, Antwerp, 1977, no. 158; W. Stechow, *Rubens and the Classical Tradition*, Cambridge, Mass., 1968, pp. 29–30.

This important drawing is after an antique bust that was thought to represent Seneca, the Roman philosopher. It survived in several copies, one of which might even have been owned by Rubens (see M. van der Meulen, *Petrus Paulus Antiquarius, Collector and Copyist of Antique Gems*, 1975, pp. 17, 83; M. Vickers, "Rubens' Bust of 'Seneca'?" *The Burlington Magazine* 119 [1977], pp. 643–644). He probably made the elaborate drawing as a design for Lucas Vorsterman's series of twelve engravings of Greek and Roman emperors and philosophers. Many of the engravings are dated 1638. It is probable that the drawing is earlier.

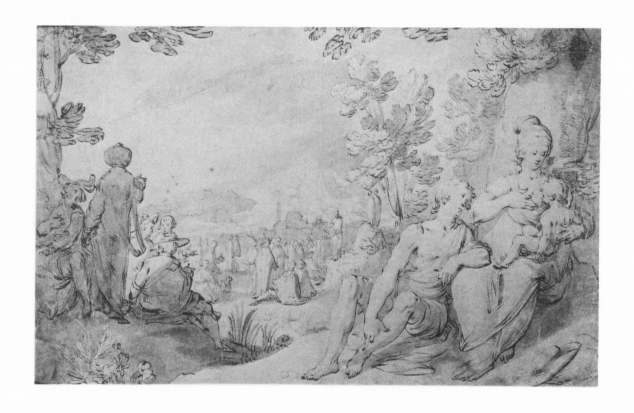

GERRIT PIETERSZ SWEELINK, Flemish-Dutch, Haarlem, Antwerp, Rome, Amster-
dam, 1566–before 1645

66. *The Sermon on the Mount*

Pen, ink, and brush with light blue and brown washes on paper, 24.5 × 29.4 cm.

BIBLIOGRAPHY: Sotheby & Co., *The Sale of the H. S. Reitlinger Collection, Part VII*, London, June
1954, lot 794.

WORKS ABBREVIATED

H. U. Beck, *Jan van Goyen, Ein Oeuvreverzeichnis*
Beck, H. U. *Jan van Goyen, 1596–1656, Ein Oeuvreverzeichnis in Zwei Banden*. Amsterdam, 1972.

O. Benesch, *The Drawings of Rembrandt*, 1954–1957
Benesch, Otto. *The Drawings of Rembrandt*. 6 vols. London, 1954–1957.

O. Benesch, *The Drawings of Rembrandt*, 1973
Benesch, Otto. *The Drawings of Rembrandt*. 6 vols. London, 1973.

Cincinnati
Cincinnati Art Museum. *The Lehman Collection, New York*. Cincinnati, 1959.

M. Jaffé, *Jordaens*
Jaffé, Michael. *Jacob Jordaens 1593–1678*, exhibition catalogue. Ottawa, National Gallery of Canada, 1968.

R. Kann Collection
Catalogue of the Rodolphe Kann Collection, Pictures. Vol. II. Paris, 1907.

Oppenheimer sale
Christie, Manson & Woods. *Catalogue of the...Collection of Old Master Drawings...formed by...Henry Oppenheimer...sold ...July 10, 13–14, 1936*. London, 1936.

Paris
Paris, Musée de l'Orangerie. *Exposition de la collection Lehman de New York*, exhibition catalogue. Paris, 1957.

Rembrandt Drawings from American Collections
Pierpont Morgan Library. *Rembrandt Drawings from American Collections*, exhibition catalogue. New York, 1960.

Rembrandt after Three Hundred Years
Art Institute of Chicago. *Rembrandt after Three Hundred Years*, exhibition catalogue. Chicago, 1969.

Guidebook
Szabo, George. *The Robert Lehman Collection, A Guide*. New York, The Metropolitan Museum of Art, 1975.

Tricolour
Szabo, George. *Tricolour: Seventeenth Century Dutch, Eighteenth Century English and Nineteenth Century French Drawings from the Robert Lehman Collection*, exhibition catalogue. New York, The Metropolitan Museum of Art, 1976.

Published by The Metropolitan Museum of Art, New York
Bradford D. Kelleher, Publisher
John P. O'Neill, Editor in Chief
Polly Cone, Editor
Doris L. Halle, Designer